PORTRAIT
PAINTER'S
HANDBOOK

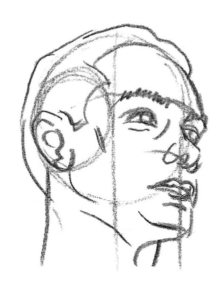

Portrait Painter's Handbook

First edition for the United States, its territories and
dependencies, and Canada published in 2014 by
Barron's Educational Series, Inc.

English-language translation © copyright 2014 by
Barron's Educational Series, Inc.
English translation by Michael Brunelle and Beatriz Cortabbaria

Original Spanish title: *Manual del buen Retratista*
© Copyright 2013 by ParramónPaidotribo—World Rights
Published by ParramónPaidotribo, S.L., Badalona, Spain

All inquiries should be addressed to:
Barron's Educational Series, Inc.
250 Wireless Boulevard
Hauppauge, NY 11788
www.barronseduc.com

ISBN: 978-0-7641-6582-5

Library of Congress Control Number: 2012939073

Production: Sagrafic, S.L.
Editorial Director: Maria Fernanda Canal
Editors: Mari Carmen Ramos
Text: Gabriel Martín Roig
Exercises: Gabriel Martín, Mercedes Gaspar,
and Ester Olivé de Puig
Corrections: Roser Pérez
Collection Design: Toni Inglés
Photography: Estudi Nos & Soto
Layout: Toni Inglés

Printed in China
9 8 7 6 5 4 3 2 1

PORTRAIT PAINTER'S
HANDBOOK

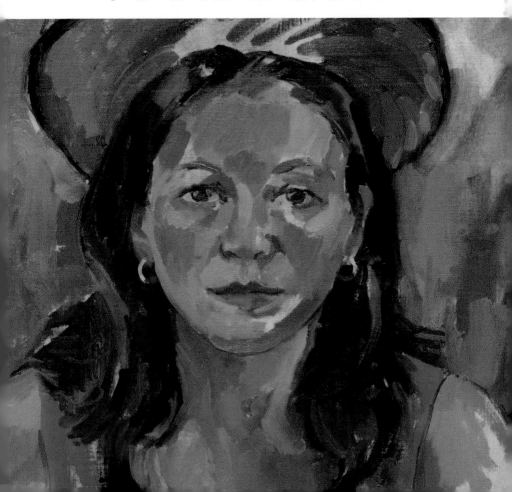

Contents

Creating a **Likeness**

The portrait is one of the most loved and exceptional themes of drawing or painting. The representation of a person is much more than a detailed expression of some physical forms, because it is not just a matter of representing the face of a particular person, with its individual features. An approach that too quickly goes to rendering the details can result in a very cold image that does not really capture the personality of the model. The success of a good portrait depends on two basic components: the first is evident, achieving a likeness of the model, but it is no less important to achieve an interpretation, that is to say, draw the features so they communicate character and reveal to us the interior world of the model.

The basic problems the artist faces when making a portrait are related to making a proportional drawing of the head, defining the facial features, and above all identifying the characteristics that will make the person immediately recognizable. Achieving this last task is the most complicated part; however, in this book we will show you some approaches that will allow you to more readily understand how it can easily be done.

First you draw the head with very elementary forms so you can proceed steadily and confidently. All the components of the face should follow some clearly defined guidelines, although after the drawing has progressed these norms may vary according to the model, and you should observe the features with greater attention to identify his or her particularities and proportions. Within all individuals is hidden a caricature that must be discovered. To do this, the painter must be a good physiognomist to capture the variations that distance the face of the model from a standard head that is based on a canon of proportions.

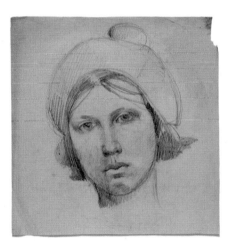

To create an accurate portrait, it is not enough to have a good knowledge of drawing theory. A sure brushstroke and the accuracy of the representation depend on meticulous observation and constant practice. By frequently making portraits, you educate your visual memory about physical forms, features, and facial expressions in different situations. The application of all this information is easier and allows you more flexibility the more you practice.

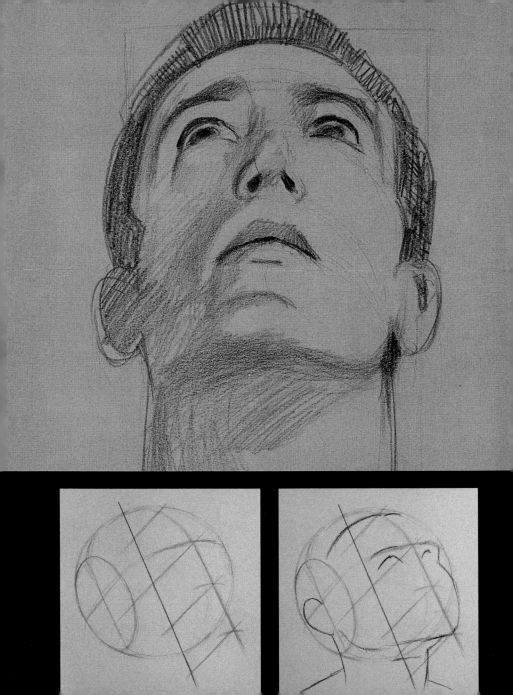

A Study of the
Head and Face

The Form of the **Human Head**

No matter how different they may be when it comes to form and expression, heads have one thing in common, their oval shape. You must begin with this basic shape to arrive at a more detailed study of its volume and create a portrait that truly is a likeness of the model. A quick look at the basic elements of the human head is enough to learn its structure and establish a preliminary layout of the features.

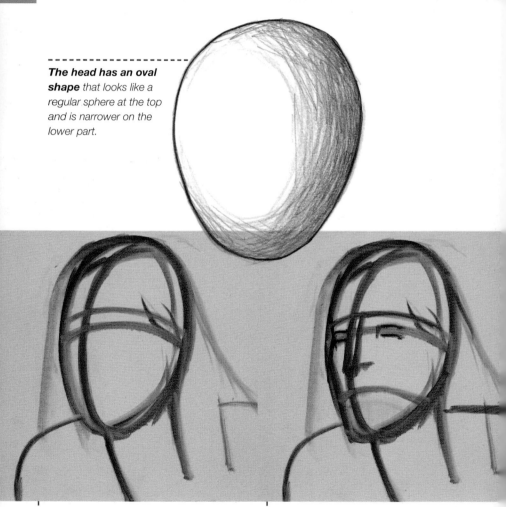

The head has an oval shape that looks like a regular sphere at the top and is narrower on the lower part.

The form of the head can be sketched as an oval. This simple geometric shape is the basic reference, the starting point.

Draw an axis that crosses the face from top to bottom, and locate the features, noticing the distances between them.

Shape of the Head and Angle of the Face

On a head viewed from the front, the character of the physiognomy is primarily expressed by the shape of the head, which according to the model can have a tendency that is triangular, oval, long, or round. Then you must look at the prominent features: short or long neck; large or small, lively or dull, round or narrowed eyes; and a pointed, flared, pug, or curved nose.

The First Synthesis

The first representation of the head should be very elemental; you must resolve the structure with a very simple drawing. This preliminary drawing starts as an oval, which will be a simple representation of the cranium, divided in two with a vertical line known as the center axis. Then some horizontal lines are drawn to indicate the placement of the eyes, the nose, and the mouth. You will discover that in nearly all heads, the eyes are situated almost in the center of the height, and if there is a lot of hair, it and the forehead occupy almost the whole top half.

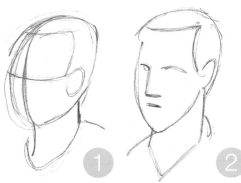

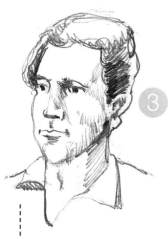

Here is another example done in pencil. Divide the initial oval with two curved axes that are adapted to the roundness of the head (1); then mark the position of the eyes, the nose, and the mouth (2). Finally, define the features (3).

This simple layout allows you to clearly locate the position of each one of the elements of the face.

Proportions and Layout of the **Face**

One of the classic chapters in the study of the human head corresponds to the proportions. Constructing the head understood as a volume is simple if you follow the guidelines for the proportions provided in anatomical studies, which indicate how to establish relationships of size among the different parts of the face and create a harmonious balance. Studying the structure of the human head will give you a scientific view of its physiognomy.

The head seen from the front can be divided into three and a half modules in height, while the width is equal to two and a half modules.

The width of the eyes approximately equals one half of a module. The distance between one eye and the other is equal to the width of one eye.

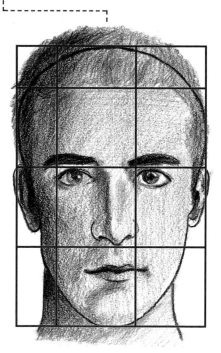

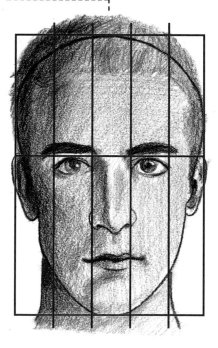

Structure and Proportions

The canon for the human head seen from the front is three and a half times the height of the forehead (from the hairline to the eyebrows) by two and one half modules in width. Dividing the bottom module into two halves will give you the lower line of the mouth. The width of the eyes is equal to the space between them, the width of the nose. The head in profile is rounder and can be fit into a grid of three and a half modules in each direction. The same horizontal divisions applied to the head seen from the front coincide with the profile, keeping in mind that the modules are identical in size to those used to lay out the head in the front view.

Geometric Diagrams

The classic canon usually brings up the mathematical relationship between the different parts of the face; however, in reality simple geometric diagrams are used. The task of constructing geometric shapes can be completed with a light shading, which will look similar to a polyhedron with a tonal gradation of flesh tones. The planes most exposed to light will be a light pink color, while the opposite sides will be a dark brown. Logically, the area of the hair will be a different color than the face, and the hollows of the eyes and the outline of the nose will look darker.

Another way of constructing the head is based on regular volumetric forms, that is to say, superimposed geometric planes whose tones are lighter or darker according to how exposed they are to the light.

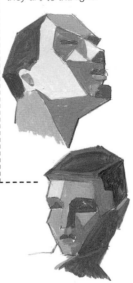

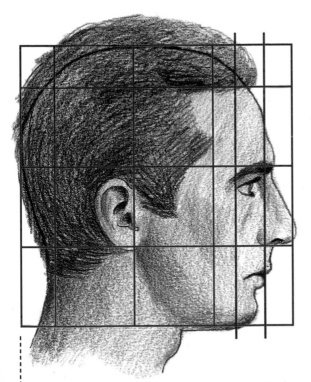

The head seen in profile form a perfect square of three and one half modules in height and width. The modular divisions make it easier to place the ear, the eyes, and the mouth.

A Measuring System for the **Front View**

In this section we will put into practice a simple measuring system that will help you place the different elements of the face in a very simple and proportionate manner, when you have a completely frontal view of the model. To best understand how to apply it, take a photograph of the person you wish to make a portrait of. Then, draw the framework or geometric diagram shown below on your paper or canvas.

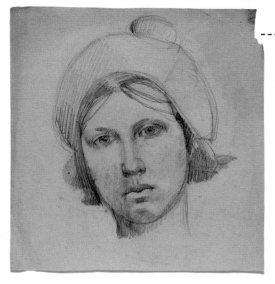

When you have a front view, *a geometric framework will be a great help in placing the elements of the face in a proportionate, harmonious, and synthetic manner.*

Each eye occupies the two central segments, *and the nose and the length of the mouth are located by crossing two straight diagonal lines. You must be sure to make the facial elements coincide with the measurements provided by the framework.*

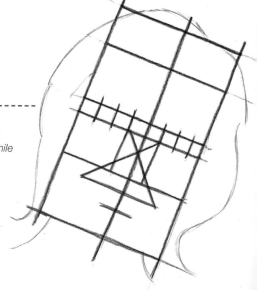

If the head is inclined, *the axis of symmetry on the face must be inclined as well. Its height is three and a half parts, while the two parallel straight lines that indicate the eyes are divided into eight parts.*

Developing the Diagram

This is a process of constructing the head using a few simple geometric shapes and crossing lines in an attempt to bring coherence to the proportions of the face. Draw a rectangle formed by two squares divided vertically in half to establish the axis of symmetry; make sure that the head is inclined a few degrees to the right rather than being exactly vertical. Divide the height of the rectangle into three and a half parts. The two parallel lines are placed at the height of the eyes and divided into eight equal parts. The two central segments in this row indicate the width of the nose, and two perpendicular straight lines project from here. At the points where these two lines cross the lower line of the square segments, draw two downward lines at 45 degrees that cross and are used to indicate the nostrils and the width of the mouth.

From the Diagram to the Drawing

You can then begin to draw over the geometric diagram. The upper division of the rectangle shows the hairline, where the forehead begins. The eight horizontal divisions at the height of the eyes can be used to mark the width of each eye and lay out the interior part. Block in the nostrils with a simple curve and the length of the mouth at the base of the previously drawn triangle. Be careful. These measurements do not always line up exactly, not all faces are perfect or ideal, but they help make a frontal portrait look well proportioned from the start.

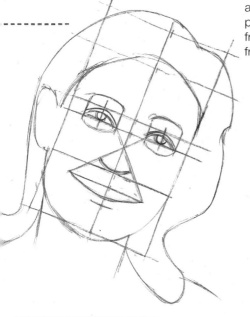

In this final phase the drawing becomes more important than the geometric diagram. Now it is a matter of modifying the shapes and the details to make it look more like the model, even though this means departing from the preliminary diagram.

A Study of the **Infant Head**

The portrait of an infant differs considerably from that of an adult. The shape of the face of a child does not have hard features, the lines are more rounded, the size of the head is large in comparison to the rest of the body, the nose is small, the cheekbones and chin are less prominent, the physique of the limbs is chubbier, and the hands are shorter and rounder.

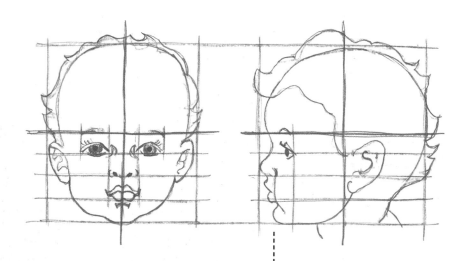

The infant head *is not subject to the classic canon of proportions of the adult head. It has its own relational measurements, which change with age. Here is an example of a one- or two-year-old child.*

The face of a young girl is sweet, *and it is dominated by the small nose and large eyes. The shadows should be very smoothly modeled and not have harsh contrasts.*

The Infant Face

A baby's head is very large in comparison to its body, and it has a more rounded shape. The face also has some notable morphological differences in respect to that of an adult. The forehead is high, clear, and sometimes even a little more rounded and prominent. The eyes are large in comparison to the face; the distance between them is greater than that of adult faces. The ears, although proportionally of greater size, are lower. The nose is small, the nostrils are more visible, and the chin is rounder and not very prominent. The mouth is small and fleshy; the cheeks are round and rosy.

Preadolescence

When a child arrives at preadolescence, his or her face looks more similar to the features of an adult. Despite this, the eyebrows, the ears, and the eyes are still low, which means that the line of the eyes still does not occupy the center of the head. The face is longer because the jaw has developed, although its outline is not very angular, and it generally continues to look rounded. The eyebrows are heavier, while the hairline along the forehead has notably increased and encroaches more on the forehead.

When painting the portrait of an **infant,** *you must consider above all the large size of the eyes. Be sure to carefully draw their outline to make them more important.*

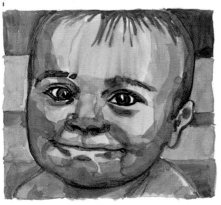

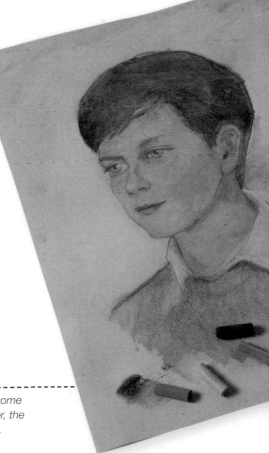

In adolescence, the head of the child has become longer, and the jaw is more prominent. However, the features continue to be smoother and rounded.

THE SUBJECT

A Study of the **Head in Old Age**

Representing older people provides greater artistic possibilities than portraits of models of any other ages. This is because facial features like the nose and ears are of greater size, and therefore more prominent. The features are much more marked, and they offer more evident reference points that make the construction and drawing of the face easier.

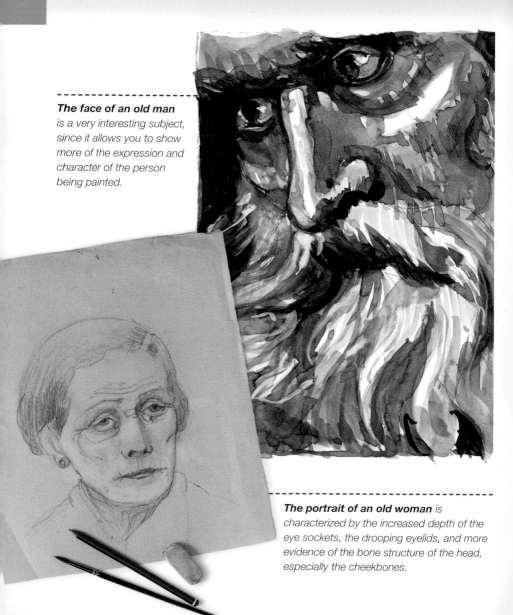

The face of an old man *is a very interesting subject, since it allows you to show more of the expression and character of the person being painted.*

The portrait of an old woman *is characterized by the increased depth of the eye sockets, the drooping eyelids, and more evidence of the bone structure of the head, especially the cheekbones.*

Physical Particularities

Representations of old people follow the classic canon, but they have a few physical particularities that are best not ignored: a higher forehead caused by a tendency toward balding, greater evidence of the bone structure of the head, sharper angles in the temples, deepening of the eye sockets, looseness of the skin and sagging chin, and the accentuated cheekbones. The wrinkles are the greatest influence on the person's expression. All these elements make painting the portrait of a senior citizen an exercise similar to making a caricature.

Wrinkles

In aging, the skin loses elasticity and sinks or hangs on the face, giving in to gravity. It looks like the bones are nearer to the surface. The rough and loose texture of the skin creates numerous wrinkles on the forehead; around the eyes, the mouth, and the neck; and just under the chin. Wrinkles should be seen as tiny folds that create a shadow, and they should be treated in detail, applying a light gray to the most evident ones.

Wrinkles are tiny folds *that can be seen around the eyes, the mouth, and the inner cheeks and under the neck.*

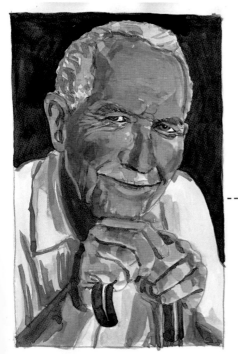

Portraits of people of advanced age *are easier for beginners to do, because they have many more references or details for personalizing the image than are present in infants and adults.*

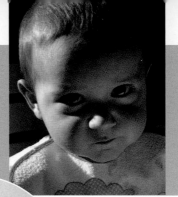

A Child in **Pencil and Watercolor**

This model is barely one year old. The play of light and shadow and the fixed gaze directed at the viewer gives it a strong visual impact.

2. *The shining eyes should be reserved, or masked, by making a small mark with a grease or oil-based pencil that will resist the watercolor wash. This is very important for creating a sweet and tender gaze.*

1 ------ **2** ------ **3**

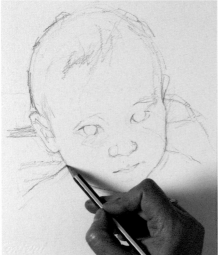

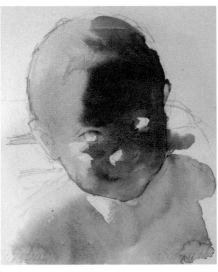

1. *Use a graphite pencil to draw the very round head. The eyes are large, the nose is small, and the mouth is small and delicate. Make continuous, thin lines with no breaks or sharp angles.*

3. *Paint the bib with a preliminary blue and violet wash. Then address the face with a mixture of sienna and a little violet for the shaded half and a very diluted wash of sienna for the light skin tones.*

Here we will use a very simple exercise to practice what you have studied so far, the face of a child who is barely one year old. It is important to take note of all the characteristics we have mentioned before when making the preliminary pencil drawing (round head, large eyes, etc.), and then continue by carefully building up the figure's flesh tones and clothing. We will be using the medium of watercolor for this exercise.

ROUND HEAD, LARGE EYES ...

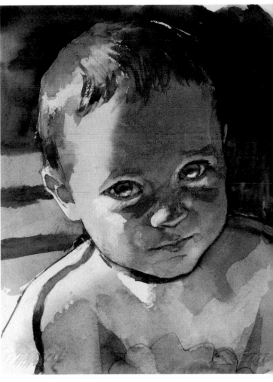

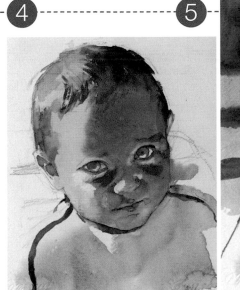

4. *Work on the texture of the hair using a fine brush on the dry painting, emphasizing the darkest locks of hair. Apply a first wash to the eyes and lips, and highlight the volume of the nose and the shadows below the eyes.*

5. *Continue adding new washes over the previous ones to darken the irises of the eyes, add a larger number of shades to the skin, and detail the chin. Use Payne's gray to paint the background, which is covered with simple, vague strokes of paint.*

Jean-Auguste-Dominique Ingres
(1780-1867)

Ingres was born in 1780 in the French city of Montauban and is one of the last great artists of the French Neoclassical style.

Portrait of Mme. Poussielgue, *1834.*
In this drawing Ingres shows a great fascination for the face of the model, which is seen to be more detailed than the rest of the body, much more resolved than the rest of the sketch. The clothing is rendered as a play of many fine, ornamental, and flowing lines. The simpler the lines and the forms on the dress, the stronger and more beautiful it seems. The shading of the face is made with repeated passes with the pencil that create a gradation that does not show any hint of the lines made with the graphite point.

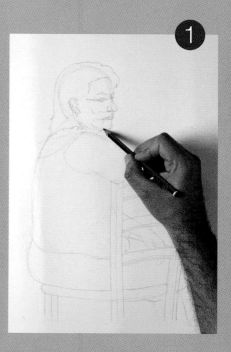

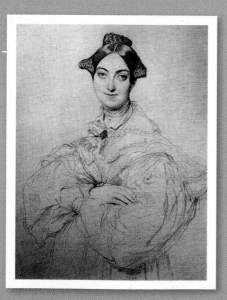

1. *In the following exercise we will make a portrait with a graphite pencil, inspired by the approach used by Ingres. Begin with a very careful outline that will emphasize the modeling of the shadows on the face.*

2. *After blocking in the general proportions of the figure, go back over the outline of the face and the facial features. The line should be very light in the illuminated areas and dark in the areas of shadow.*

Ingres is famous for his extraordinary range as a portraitist. In fact, all the great figures of 19th-century France were immortalized in oil by him. The graphite pencil portraits, on the other hand, done to satisfy his friends, relatives, and acquaintances, were not meant for the greater public. In these small-format works we can identify two features that appear as a constant aesthetic of his style: the first is the intensity of the line used to outline and synthesize the silhouette of the model in a single stroke, and the second is the smooth modeling of the face that reminds us of ancient marble statues.

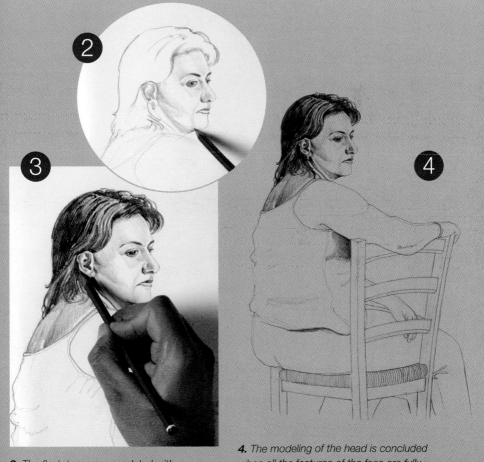

3. The flesh tones are modeled with gradations that render the volume, and in which the pencil lines almost disappear. The outline of the mouth, the nose, and the eyes are drawn with darker and thicker lines, like those of the hair.

4. The modeling of the head is concluded when all the features of the face are fully detailed. The shadows on the skin are very light, while the hair shows heavy wavy lines that emphasize the texture of the strands. The rest of the body is barely indicated with a fine line.

The Eyes and the Eyebrows

Before you can make an accurately detailed drawing of the head, it is necessary to study the face and become familiar with its forms in different views: the eyes and their irises, the shape of the nose, the mouth, and the ears. There are four basic elements: the eyes, the nose, the mouth, and the ears. You must learn how to represent each of them, beginning with the eyes, which are the source of the expressive strength of the portrait.

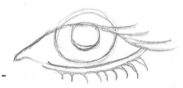

The iris is partially hidden by the eyelid.

The eye can be drawn as a very symmetrical shape (a). However, it is more curved on the upper part than the lower (b).

The eyelashes look like they are all on the outer half of the eye.

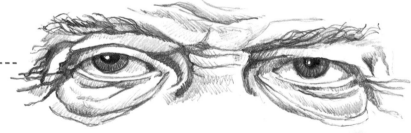

The eyes and their gaze are the main expressive elements of the portrait, since they contain the personality of the person being depicted.

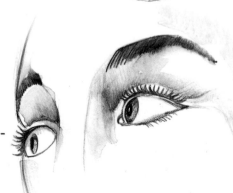

An accurate representation of the gaze depends on coordinating both eyes.

Placing the Eyes

The eyes are a magnet that attracts the viewer's attention, and are a key element in communication, so they should play a central role in the portrait. They are aligned symmetrically, located in the center of the face. When drawing them, you must consider the spacing, the distance between the eyes and above the nose. The distance is always equal to the width of one eye. The most common mistake made by beginners is placing the eyes too close to the nose, and this can throw off the other elements of the face and ruin the drawing.

In an eye seen from the front, the iris looks completely round (a).
In a three-quarter view, the spherical form of the eyeball is more evident, and the circular shape of the iris becomes more oval (b).
In a side view, the iris can be clearly drawn as an ellipse (c).

Eyeball, Eyelids, and Eyelashes

The eyes are spherical, they are aimed in the same direction, and their movements are perfectly coordinated. When the eyeball rotates, the iris is no longer perceived as round but looks more like an oval. Both the eyelids and the eyebrows are accessories that protect the eyeball. The curve of the upper eyelid is more pronounced than that of the lower one, which is much slighter. The eyelashes on both eyelids do not grow along the entire perimeter, they are more to the outside of the eye, and are longer and thicker on the upper eyelid than the lower one. The eyebrows are located on the brow above the orbital cavities, and they tend to follow the shape of the brow. They are thicker and more prominent on men and thinner and more curved on women.

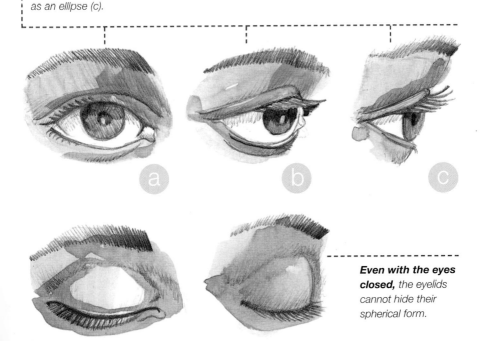

Even with the eyes closed, the eyelids cannot hide their spherical form.

The Mouth and the Lips

The mouth, along with the eyes, is among the most expressive part of the face. Despite its apparent simplicity, drawing it is somewhat complex, since the lips cannot be drawn with a simple straight line. Furthermore, their muscles can give them extremely complicated shapes, depending on the facial expressions. The instructions given in this section are especially important, since they will help you place and define these features from any point of view.

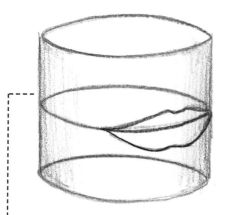

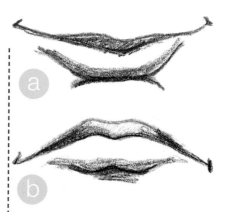

The mouth should begin as a shape on a cylindrical surface. *From here it is adapted to the curve of the face.*

The corners of the mouth mark the curvature of the face *in a front view (a). The curvature is maintained despite changing the view, seen from below (b).*

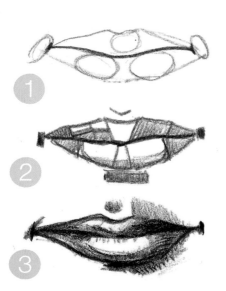

A simple diagram for learning to draw the lips. *A curved line and a few circles determine its form (1). The different planes are indicated with geometric forms that define their volume (2). The previous steps culminate in the final drawing and shading (3).*

Drawing the Mouth

In a front view, the symmetry of the mouth is very important. When you draw it, you must calculate its width using the length of the nose as a reference. First mark the central axis to align the mouth, and then mark the point where it ends, in relation to the corner of the eye. Look at the centerline of the mouth, and draw an exact curve, which is very important for capturing the expression of the model. If it is closed, first draw the curved line between the lips. Then complete the top and bottom edges of the lips with a light line, because these are not strong outlines or edges.

The Lips

The upper lip is defined by a fold or indentation in the center and by the fact that it is longer than the lower one. The lower lip is shorter, fleshy, and rounded. When drawing the lips of models, you will notice that there are different types: thick, thin, wide, narrow, fleshy, voluptuous. This is especially true when it comes to female models.

When painting, it is important to accentuate the difference in the tones of the upper lip and the lower one. The upper one, under normal lighting conditions, is always in more shadow than the lower one. The bottom edge of the lower lip is visible because of the shadow it projects on the chin.

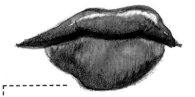

There are different kinds of lips, *and especially more variations in female faces. In this case a mouth with thin lips is shown.*

Here the upper lip is more curved, *and the lower one is more rounded and fleshy.*

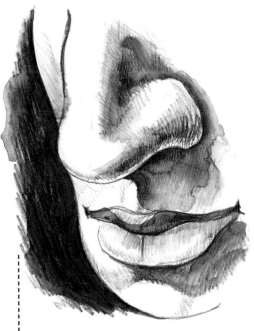

The upper lip is usually more shaded than the lower one, *which is defined by the shadow that it projects on the chin.*

THE SUBJECT

The **Nose**

Drawn in profile, the nose offers few difficulties, but representing it from the front or in a three-quarter view requires using the references of the shadow at its base and the gradations that model its sides to define its limits and render its shape.

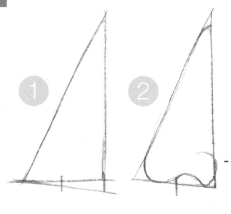

The profile of the nose is constructed using a triangular shape to create its outline (1, 2). After a few small adjustments to personalize the nose, erase the initial sketch and add shading (3).

A good way of understanding the nose from the front is to construct it using simple geometric shapes.

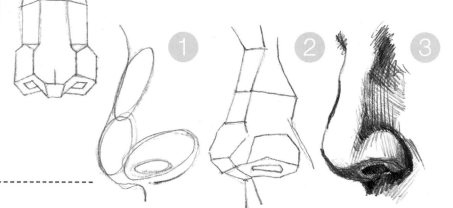

Use three circles or ellipses to indicate the bridge of the nose and the nostrils (1). The next step consists of adapting these shapes to a more geometric scheme (2). Erase the original sketch and fill in the shadows with hatched lines (3).

From Sketch to Finished Representation

Drawing the nose in profile is very simple. First you project a triangle, and then you draw the shape inside it. When drawing it from the front or in a three-quarter view, you must change that triangle to a volumetric form. The bridge of the nose can be laid out within a long triangular shape, while the lower part can be stylized with a trapezoid shape where the nostrils protrude. Drawing the outer parts of the nostrils will help you perceive the shape of the spaces that surrounds the nose. The orifices should be finished by darkening them slightly to give them the needed depth.

Shading Is the Key

The key to drawing the nose in the front view, or when you do not have a clear profile, rests in literally rendering the play of light and shadow, which will help to emphasize the volume and reinforce its prominence. You must keep in mind that the lower part of the nose is always in a shadow, and that the bridge always has a long highlight, and these tips will make the nose look three-dimensional. Finally, remember that the transition from the nose to the forehead does not show any significant changes in young people, but in older people there can be a very visible ridge or brow.

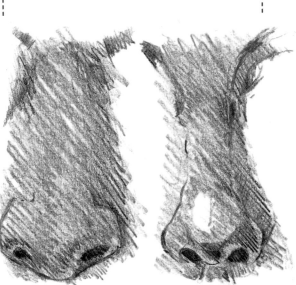

When the nose is seen straight on, its shape is suggested through the use of light and shadow, which makes it look more or less prominent.

You must always consider the point of view, since the nostrils will be more or less visible based on it.

The **Ears**

The ears are the least appreciated part of the face, elements that young painters barely take notice of. This is in spite of the fact that, curiously, the ear is the easiest facial feature to draw; however, through lack of attention it is usually drawn badly. In a frontal view the ears are a continuation of the plane of the face, but in a rear view they stand out from the plane of the back of the neck.

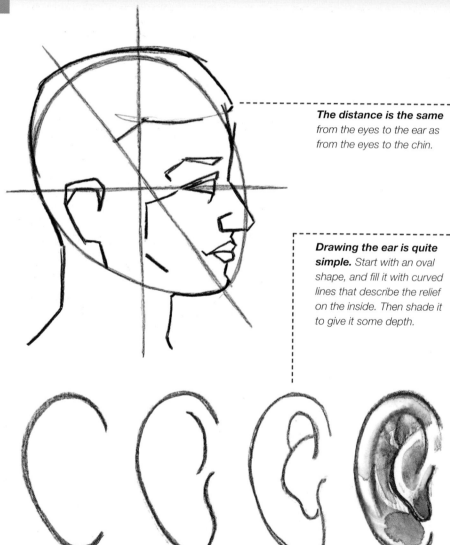

The distance is the same *from the eyes to the ear as from the eyes to the chin.*

Drawing the ear is quite simple. *Start with an oval shape, and fill it with curved lines that describe the relief on the inside. Then shade it to give it some depth.*

The Ear from the Front

You must judge the position of the ear by eye, placing it quite far back on the head. The distance between the edge of the eye and the back edge of the ear is approximately equal to the distance from the level of the eyes to the chin. If necessary, you can measure the model to check this relationship. To accurately draw the ear, you just have to approximate its basic structure: its oval shape and its concave volume. From a frontal point of view, it can be drawn with an initial sketch using two very basic geometric shapes, a large circle to represent the concave part of the ear, and a smaller circle to represent the ear lobe.

Rear View

When the ear is seen from a three-quarter view, it is somewhat more complex, but this obstacle can be overcome with a little practice. It has a curving form that is similar to a ceramic bowl. This can be seen when you look at the cavity of the ear from behind, where it clearly has a hemispherical form. A word of caution: no matter the position of the ear, its cavity should not be shaded very darkly or it will look like a hole rather than a plane in the drawing or painting.

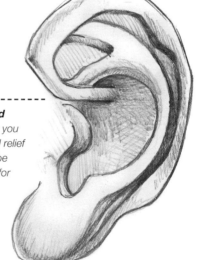

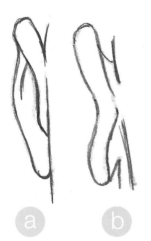

This is a detailed study that allows you to see the internal relief of the ear. It can be used as a model for future portraits.

The ears are rarely seen straight on, so it is helpful to know how to draw them from the front view of the head (a) and the rear (b).

To best understand the morphology of the ear, it is useful to draw it from several points of view and apply light shading to give it volume.

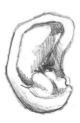
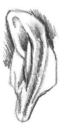

Capturing the **Expression**

The human passions are best reflected in the face; thus, the various states of mood and the emotions can be seen in the expression. The play of the facial muscles model and communicate the feelings that are experienced by the model, in cheekbones that stand out more or less, the shape of the mouth, the wrinkling of the brow, the arch of the eyebrows, and so forth.

It is best to draw yourself standing in front of a mirror. Begin with a smile, the eyes become smaller, the mouth opens, and the eyebrows go up.

The complexity of the numerous muscles of the face allows you to easily make an infinite number of expressions. When you tightly close your mouth, it widens, the face shortens, and both eyes open more.

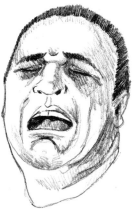

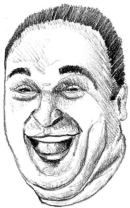

In an expression of anger or weeping, the nose flattens, the jaw widens, and the brow lowers in a frown.

When you laugh, the jaw drops and causes visible folds under the chin; the eyes get smaller, and the eyebrows arch.

These two pages present a series of sketches of expressions, a glossary that shows a variety of faces that can indicate joy, sadness, surprise, irony, stubbornness, and other emotions. Here you can see that the eyes, the eyebrows, and the mouth are the parts of the face that change the most in relation to the states of mind of a person.

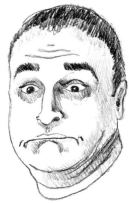

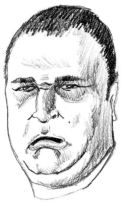

Do not be shy, *or afraid to look funny, it is a matter of being silly in front of the mirror to experiment with atypical facial expressions.*

With an expression of disgust, *the eyebrows descend causing wrinkles at the top of the nose, the eyes become smaller, the nostrils go upward, and the mouth arches.*

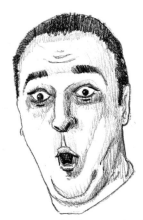

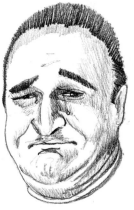

The main thing about a surprised face *is the noticeable lengthening of the face and the shapes adopted by the mouth and eyebrows. It is a very expansive-looking face.*

The face contracts with a sad expression; *the jaw tightens and makes it look rounder. The eyebrows adopt an irregular shape.*

Two Ways of
Painting the Hair

Whether you are representing dark hair that looks homogenous or hair that is blonde and tied up, you must pay attention to the dark areas where the hair forms waves or bends and to the coloration of each lock or strand.

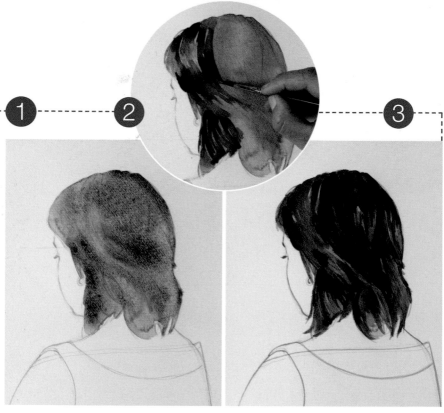

1. First make an accurate pencil drawing of the head. Mark the direction that the hair is combed with lines. Paint the hair with a wash of sienna mixed with burnt umber.

2. Let the painted wash dry. Then use a mixture of burnt umber and Payne's gray to paint the darkest strands of hair, leaving the highlights and lightest areas unpainted.

3. After the wash has dried, add some new tones, for example some touches of reddish sienna in some parts of the hair.

The brushstrokes should always follow the direction that the hair is combed.

The hair is not finished with a simple wash or in a symbolic manner by building up a series of more or less wavy brushstrokes. You must learn to draw it in the same way as the other elements of the face, seeing it in all its complexity. You must represent the generic form of the hairstyle and the characteristic texture, building up the strands with lines and brushstrokes, focusing on the waves and curves that describe the hair. Let's look at two graphic examples done in watercolor.

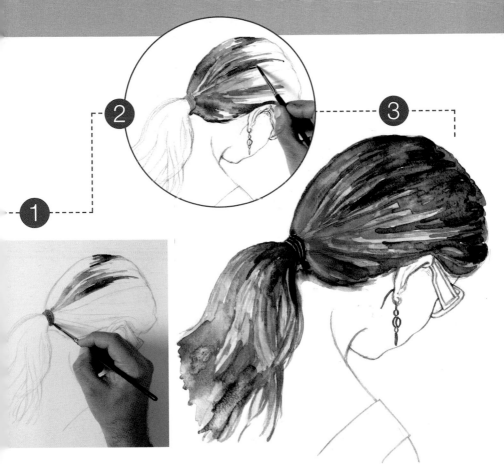

1. Here, to paint the blond hair tied in a ponytail, we choose to apply the paint alla prima instead of in layers. Starting at the ponytail, we apply a color that fades and blends with others as it moves up the head.

2. It is a matter of creating a scale that goes from ochre and orange tones in the lightest parts of the hair to burnt umber in the darkest strands.

3. The hair is in tension on the head, so the brushstrokes will be longer. On the ponytail, however, the more relaxed hair can be approached with a looser and wetter technique.

Berthe Morisot
(1841–1895)

--

Berthe Morisot, one of the best-known French Impressionist painters, gave her brush full rein in creating portraits with an extraordinary energy.

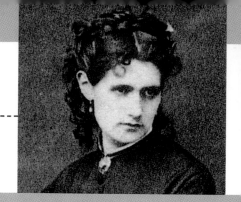

The Evening Toilette, *1886.*
Morisot constructed the figures with a visual shorthand of dabbed brushstrokes that placed her at the vanguard of the artists of her era. The hair, the face, and the clothing reveal an overlaying of nervous, inexact, and dynamic brushstrokes. While the face is the most detailed part of the painting, the background looks unfinished, leaving the beige color of the support uncovered. The way that the light spreads through the interior, eliminating the details, makes her painting daring and modern.

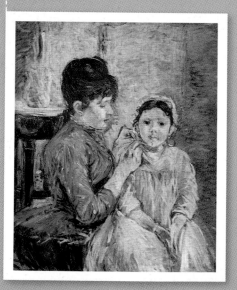

1. *To paint an oil portrait in the style of Morisot, you must first cover the entire canvas with very diluted sienna. Use the same color to draw the figures with a fine round brush.*

2. *Work on the faces first. Paint them by blending together several strokes of different flesh tones. Use burnt umber to paint the hair, the eyes, and the eyebrows. The brushstrokes should generally be loose and a little more nervous on the hair.*

Born in the south of Paris, she began as a copyist in the Louvre, which allowed her to become familiar with the techniques of the old masters. In 1868 Eduard Manet was so impressed by her painting abilities that he introduced her into his circle of friends. Thanks to those contacts Morisot's work began moving toward the style of the emergent Impressionist group. She began to elaborate her compositions using color and brush marks in such a way that, even though the representation of the figures, the volumes, and the forms are evident, they are more insinuated than visually present.

4. The most detailed areas are the faces, where you can clearly see intentional modeling. The rest seems to be made up of brushstrokes that give the painting a fresh and unfinished look. This unfocused color helps to direct the viewer's attention on the portrait of the mother and the child, and not distract them with other details in the painting.

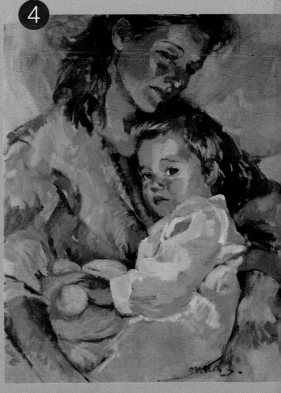

3. Continue adjusting the details on the faces to achieve a likeness of the models. Partially cover the background with blue and pink brushstrokes. The clothing is painted with very thick, long, and gestural strokes, leaving small spaces where the background shows through.

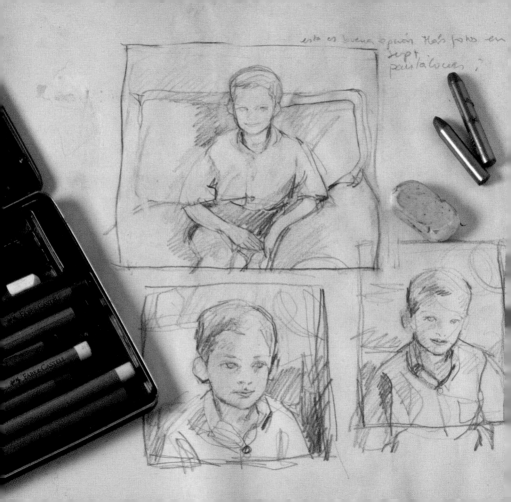

esta es buena opinón Más fotos en
Sept.
pantalocas ;

Composition and
Framing

Once you have studied the general proportions of the head, the different measuring systems, and the shapes and placement of the elements of the face, you must develop a practical method for creating a portrait. Now it will be a matter of constructing a head in a quick and simplified manner, drawing it in any position and from different points of view, and using methods for blocking that you have used before and other new ones that we will introduce in this block of exercises. This will mean leaving aside a strict anatomical view of the head to make more specific portraits, capturing the pose and adapting the framing to the view of the model you wish to create.

Simplified Methods of **Blocking In**

Those of you who cannot refer to a life model can make do with photographs. You must fill your sketchbooks with drawings where you capture the essence of each model in just a few lines. Your visual acuity is developed by making a great number of notes and color sketches in an attempt to capture all the different possible positions of the head.

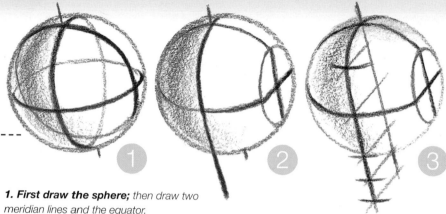

1. First draw the sphere; *then draw two meridian lines and the equator.*

2. The lateral sections of the sphere *are drawn as if they were flat, and the meridian line is extended.*

3. Extend the axis of the sphere, *and then indicate the proportional divisions of the head.*

4. Place the different facial features *on the marks that are projected from the vertical axis.*

By slanting the angle of the axis of the sphere, it is possible to develop a portrait of a head seen from the side and slightly above. Then you will personalize the features so that they will look as much as possible like those of the model.

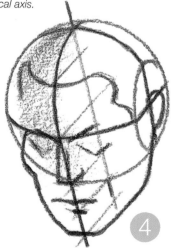

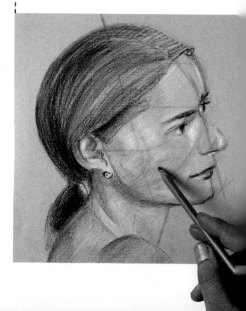

Drawing Meridians and an Equator on a Sphere

To make a three-dimensional diagram of the head, you must first sketch a sphere and draw the meridians and the equator on it. The sides of the sphere should be treated as if they were flat, and you must extend the frontal meridian, or axis of the face, downward with a straight line. Divide the straight line into three and one half parts to indicate the face, and extend the division lines across the face. Using these divisions as a reference, place the elements of the face. This construction method allows you to draw the head from any point of view.

Different Positions

The previous diagram can be used to develop the head from different points of view and poses, by inclining it to one side or the other. The line on which you mark the divisions should always be clear, enabling you to apply the basic positions of the features in the correct places. After you lay out the structure of the head, work on the character of the face: whether it is angular, rounded, or square. You must continue to draw slowly, now paying attention to the edges to describe the most outstanding features, their angles, and their sizes. Next, mark the particularities of the model's face: large or deep-set eyes; straight, rounded, or small nose; thin or thick lips; among others. You must not think about what you are drawing; just render one form and then another.

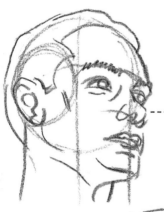

This method of constructing the head enables you to draw it from any point of view.

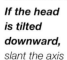

If the head is tilted downward, slant the axis of the sphere, and transfer the measurements to the vertical line of the face.

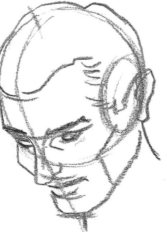

Using this diagram, you can even represent uncommon points of view like this three-quarter view of the back of the head.

The Position of the Head
and the **Direction of the Gaze**

Before you begin to draw, you must establish the angle of the inclination of the central axis of the head. The inclination is different in each case, and it is determined by the position of the body and in what direction the model is looking. If the head is oriented in the same direction as the body, the figure will look rigid or stiff, on the other hand, a slight twist or lean is more graceful, offers more variety, and gives the model a more natural feeling.

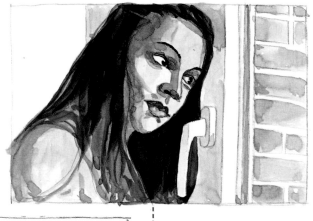

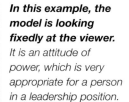

In this example, the model is looking fixedly at the viewer. *It is an attitude of power, which is very appropriate for a person in a leadership position.*

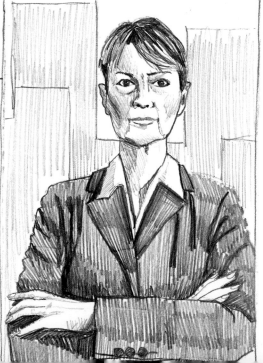

When the model gazes into the distance through a window, *the pose is sweeter and nostalgic; the viewer wonders what the model is looking at.*

When the model fixes his or her gaze on an object *within the painting or drawing, a second point of interest is created in the portrait, in this case the breakfast plate.*

Orientation of the Head Based on the Gaze

You have three different options for orienting the head, based on what you wish to communicate with the gaze. In the first case, a frontal orientation that aims the gaze toward the viewer to establish a direct link, which some artists consider to be too intimidating. The model can also look toward one side, fixing his or her attention on something that we do not see and that is outside of the picture plane. This creates a feeling of warmth and curiosity in the viewer, who wonders what the subject is looking at. The final option is to have the model look at an object that is inside the picture plane, something he or she has in his or her hand, like a book or small object. To the observer some object of this kind added to the painting becomes a secondary focal point.

The Position of the Profile

The best way to practice is to use a friend or family member that is reading or watching television. When drawing a figure in profile, it is a good idea not to sit more than 6 feet (2 meters) away or else you will not see clearly enough. Also, do not place yourself so that the light source is behind the model, because his or her face will just look like a black shadow. In a profile portrait you see the side of the head, so the model rarely is looking at the viewer, but is looking toward one side or the other. In this case, it is best to leave more space in front of the face, to create an empty area, a viewing space.

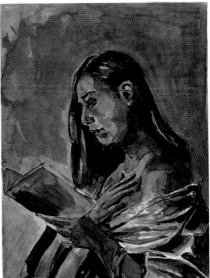

The best way to represent someone in profile is to capture him or her in a natural pose, caught in an activity like reading, for example. The book will then become a second point of interest.

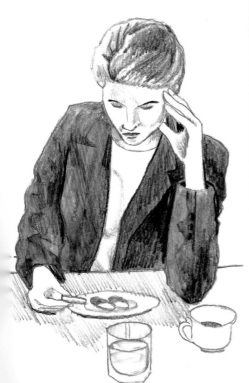

The Head in **Three-Quarter View**

On very few occasions is the head seen in a front view or completely in profile, and most portraits are made using a three-quarter view. This is because a three-quarter representation is best for showing the personality of the model and allows you to create a better likeness of the features.

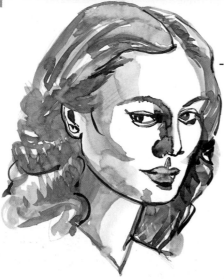

- -

The three-quarter view is the one most commonly used by portraitists because it is a very asymmetric and expressive view.

- -

When you paint a portrait in three-quarter view, the size of the eyes varies quite a lot. *The nearer one is larger than the one half hidden behind the bridge of the nose.*

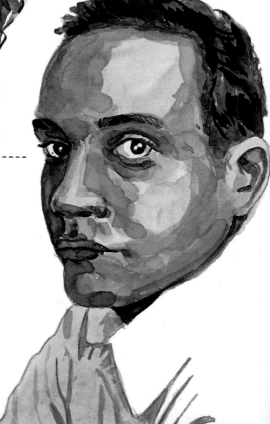

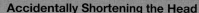

The Three-Quarter View

The three-quarter view presents a completely asymmetrical view of the face, which makes it more interesting. Drawing the nose is not as simple as when it is a profile view, and the lips are not symmetrically placed on the face, they are of a different width and are irregular in shape. The eyes are also different from each other, since one usually looks like it is larger than the other. The solution to drawing the head in three-quarter view and with foreshortening is to draw only what you see, placing each element in its corresponding position on the divisions marking the locations of the eyes, nose, and mouth.

Accidentally Shortening the Head

For many people it is difficult to correctly envision the proportions of the features of the face in a three-quarter view. Those who have little experience with this genre often make the mistake of placing the eyes too high so that the face almost occupies the total height of the head and makes the forehead smaller, robbing space from the hair, and even cutting off part of the cranium. It seems that the top half of the head is less interesting to us than the face, and we tend to shorten it. It is important to remember this and to take the appropriate steps to avoid this error.

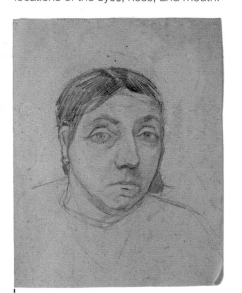

When drawing the head in three-quarter view, some beginners make the mistake of giving the face so much importance that it cuts out part of the head.

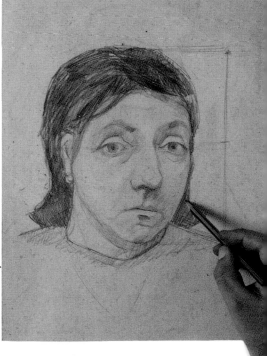

Notice this correction of the previous drawing, to which we have added the part of the head that was missing to correct the proportions. Remember that the eyes should be placed approximately in the center of the head.

Choosing the **Pose**

Portraits very rarely limit themselves to showing just the head of the model; they usually show part of the bust, half figure, or even the full figure, especially when they are of seated figures. In the latter case, sometimes the pose adopted by the model does not look very natural and seems to be rather forced. Thus, it is important to choose a good pose that encourages a warm and natural

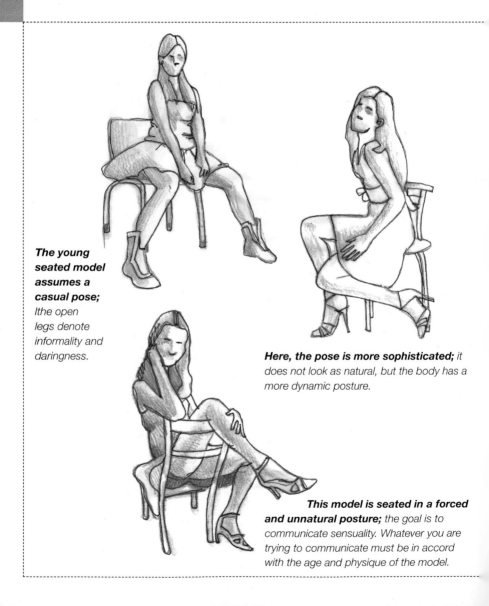

The young seated model assumes a casual pose; lthe open legs denote informality and daringness.

Here, the pose is more sophisticated; it does not look as natural, but the body has a more dynamic posture.

This model is seated in a forced and unnatural posture; the goal is to communicate sensuality. Whatever you are trying to communicate must be in accord with the age and physique of the model.

closeness to the model. To do this, it is best to make the portrait in a familiar environment, with a model who is acting naturally and doing something that he or she likes. This will make the model feel freer and more relaxed, and the poses will be more in line with the age and what you are attempting to communicate.

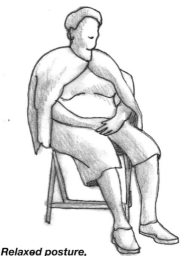

Relaxed posture, with the hands crossed, *an appropriate pose for persons of advanced age. If the pose becomes more rigid, it will lose all its dynamism.*

This is an example of a young person in a rigid pose. *The profile view encourages a representation that is too symmetrical. Your choices when framing the model are important when representing the model from this point of view.*

When painting seated half figures, *you must avoid front views whenever possible. A good solution for the composition is to seat the model sideways or to have him or her lean to one side.*

The Framing and the **Composition**

These approaches are mainly used for increasing the liveliness of the image. Their use comes down to two aspects that must always be kept in mind: the placement of the model with respect to the center of the painting and the shape and size of the framing, which will determine the closeness to the model, showing the entire figure or moving closer for a partial view.

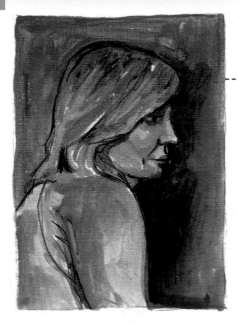

The vertical format, or "portrait," is used with greater frequency. In addition to the head, you can include part of the torso with no apparent difficulty.

The horizontal format, or "landscape," is not used very much for portraits; however, it does present some interesting compositional possibilities.

Avoiding the Center

A central composition, that is, placing the model in the center of the framing, is usually not very interesting in a portrait. It is better to frame the face slightly off-center and balance it with another element, like the slanted line of the shoulders. You can unbalance the painting even more by moving the center of interest to one side of the composition to create a more dynamic image, putting the figure at the edge of the painting. There is a natural tendency to not get close to the subject, to not cut it of, and this is a mistake. You must try to get close to the model and fill the frame so that the viewer can quickly capture what he or she is trying to see, and avoid too much empty space around the figure.

Framing

When framing the figure, many inexperienced artists get bogged down using a vertical rectangular format, the one referred to as a "portrait" format, since it reduces distractions and emphasizes the figure over the background. There are two other options: the horizontal, or "landscape" format, which creates a feeling of serenity and leaves more space in the background for scenery or decorative painting, and the "square" format, which is more static and limiting. The square sides communicate solidity and stability, but they also cause difficulties in the composition. We recommend experimenting with new formats to surprise the viewer and add variety to the composition.

The square format is much more modern; it adapts well to the figure, although you must choose the pose and framing carefully so it does not appear cut off.

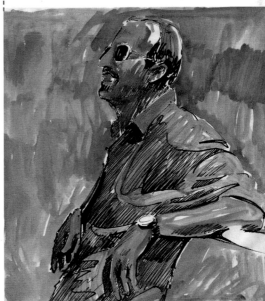

You must not be afraid to upset the balance of the composition. The model does not always have to occupy the center of the picture; he or she can be located to one side or the other to create a relationship with the background.

The Half-
Figure Portrait

For an esthetically pleasing composition we suggest that the model cross his or her arms in a pose that is neither uncomfortable nor forced.

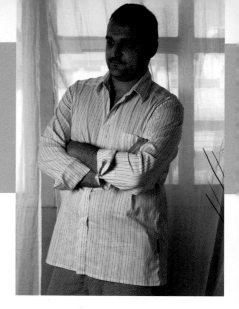

1. *The most important thing is to make a well-proportioned drawing. Begin with an oval for the head to indicate the height of the figure, and on this simple form mark the measurements for placing the eyes, the nose, and the mouth.*

2. *Put all your effort into the face and its likeness to the model, adjusting each form and each detail like the thick eyebrows, small eyes, large curved nose, and leave the rest of the figure as a sketch.*

THE POSE GIVES THE

This corresponds to what is known as the "American shot" in cinematography, where the frame cuts the figure a little below the waist. With this framing, the artist gives more importance not just to the features of the face but also to the pose adopted by the body and the arms. The positions of the hands, the arms, and the torso of the figure thus become more important factors and add variety and expressiveness to the portrait. This exercise will be painted with oils.

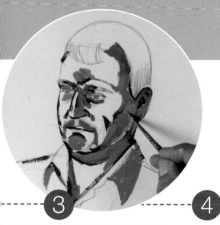

4. *The mid tones are painted using gray blue and blended with the still wet violet by dragging some of the paint with each brushstroke. Finish painting the forehead, the cheekbones, and part of the neck using a pink that also has some gray.*

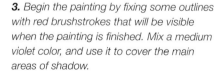

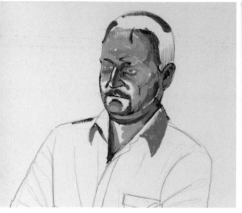

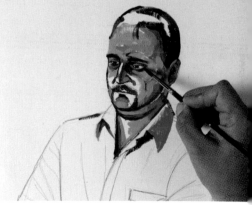

3. *Begin the painting by fixing some outlines with red brushstrokes that will be visible when the painting is finished. Mix a medium violet color, and use it to cover the main areas of shadow.*

5. *So as not to lose the reference of the initial drawing, after the first applications of paint strengthen the shape and outline of the eyes, the base of the nose, and the mouth with black violet. Do the work using a fine brush with a tip that is in perfect condition. Apply the same color to the hair, the eyebrows, and the goatee.*

PORTRAIT VARIETY AND EXPRESSIVENESS

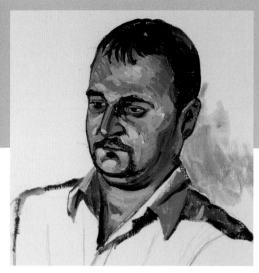

6. *Add the warmer pink and light ochre tones to the left side of the face, the more illuminated one, to enliven the dull colors dominated, until now, by violets and blues. Finish painting the hair with a mixture of Prussian blue, permanent violet, and a dab of sap green.*

7. *With the face completed, move on to paint the shirt with a very light blue gray color. The folds and shadows on the shirt can be suggested with strokes of violet applied over the still wet paint. Then begin to cover the background with diluted paint.*

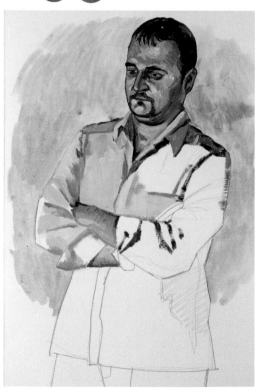

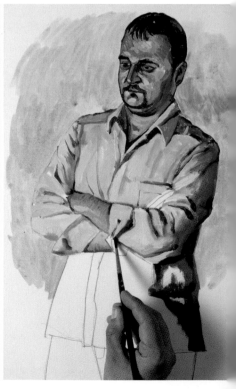

8. While the most illuminated parts are very light gray, the right half of the figure is more shaded, and painted with a mixture of medium gray and brown tones. Here the folds in the fabric are darker and more contrasting.

9. Finish the shirt with more uniform strokes on the lower part, adding a few lines with the brush to indicate the outlines, especially on the cuffs of the shirt. Darken the background so that it contrasts and creates a stronger silhouette of the half figure.

10. The pants can be painted with just three shades of gray tinted with burnt umber. Suggest the space behind the model with diluted paint, with some vague sketches to indicate the window and the curtain.

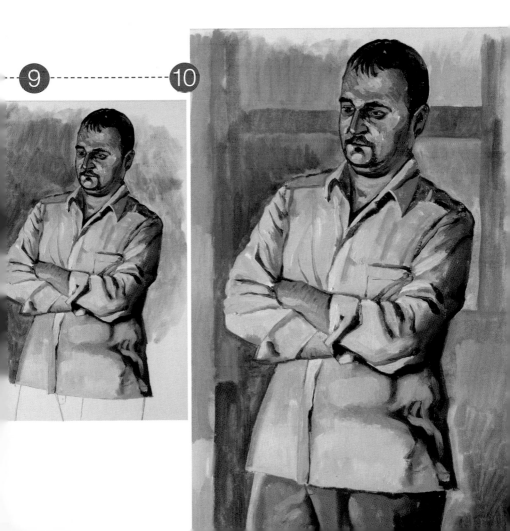

The Direction of the **Light and Shading**

Light is an important element in any painting, because it reveals the forms and anatomical structure of the face. No artist can completely master the portrait if he or she is not able to understand the qualities of light and interpret them appropriately. The modeling of the flesh tones depends directly on the direction and intensity of the light: if it comes from a very high source, the shadows will be very distinct. The greater the intensity of the light, the more the shadows contrast; on the other hand dim light softens the features and hides wrinkles on the face.

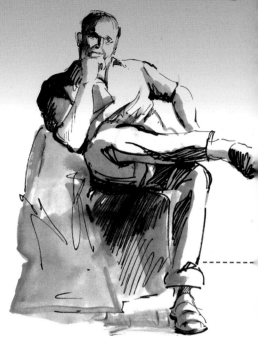

These are the main directions of the light used for painting and the shadows they create. Lateral or side lighting is the most commonly used, and it leaves half the face in shadow.

Light that comes from above is typical when the model is in full sun. It strikes the most prominent parts of the face: the cheeks, nose, and chin.

The Direction of the Light

In a portrait the direction of the light should be lateral. An angle of 45 degrees between the light source and the model creates pleasant shadows on the face. Contrarily, lighting that is too high can produce shadows that are very long and unsightly under the eyes and chin. Such large and dark shadows are not helpful to us because they unnecessarily complicate the drawing. If the face is frontally illuminated, hard features are hidden and the face looks soft; for this reason many artists choose to illuminate feminine portraits from the front.

The light, its direction, and the projected shadows are factors that highlight the volume of the figure. In addition, they help emphasize the character and strengthen the representation.

The Quality of the Light

Soft lighting makes the shadows lighter and hides the wrinkles and imperfections of the skin (the light on a cloudy day or that screened by a curtain is of this type). Hard light is spectacular and creates dark contrasting shadows; it does not favor the model, but it gives the portrait impact and strength (direct sun and spotlights produce hard light). Direct sunlight entails some problems. We cannot always control the angle of incidence and intensity, nor can we create favorable results since shadows that are too well defined and intense reflections complicate representations with too many details and very pronounced effects on the texture of the skin. For these reasons, if you choose this type of illumination, you must take some precautions.

When the light comes from below, it looks ghostly, as when the model is near a small lamp.

Backlighting leaves the face submerged in darkness, while the outline of the figure is illuminated. This is common when there is a window behind the figure.

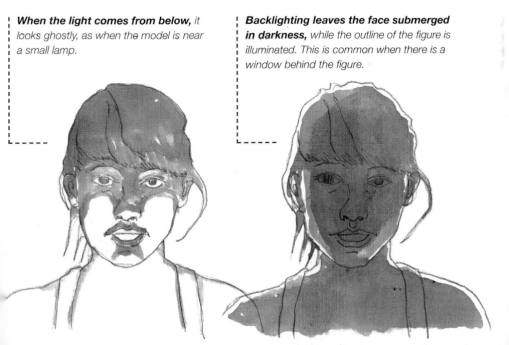

Values in the **Portrait**

Applying values to a drawing or painting means distributing the light and shadow on a model in an accurate and balanced way. The goal here is to render the forms of the face so we can clearly distinguish the parts that stand out the most as well as the grooves and hollows. In this way the contrasts among the values allow us to identify the eye socket, the nose, the chin, and the cheekbones.

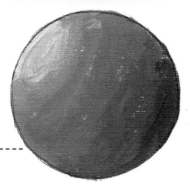

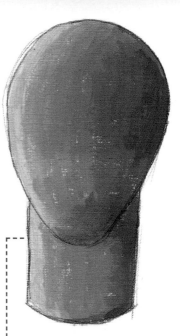

The modeling on the face looks like a sphere rendered in flesh tones: whitish tones in the part most exposed to the light and browns in the most shaded areas.

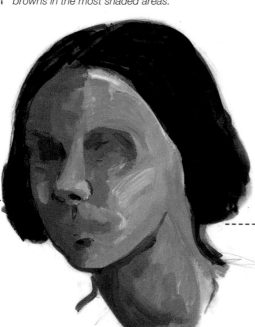

The technique of modeling a sphere is applied to the volumes of the face, which is composed of an oval that represents the head and a cylinder for the neck.

In addition to the modeling that forms the head and the neck, you must only include the shadows for the eye sockets, the nose, and that of the chin. All the tones should be blended with each other with no brusque changes.

Shading a Sphere

When painting a portrait, it is best to first apply the values of the shadows. It is not the illuminated areas or the highlights that distinguish the model, but the half tones and the shadows. Begin with the darkest value and develop a tonal scale that reaches the lightest areas. The head often has a gradation that is reminiscent of a sphere illuminated from the side to which have been added the tonal differences caused by the nose and the eye sockets, which require their own particular shading. To finish, look at other projected shadows, which are few but important: those appearing just above the eyes, below the nose, and at the base of the mouth.

Tests with Three Colors

The values of the flesh tones on a face can be treated as a quick sketch. To do this, find a photograph in the family album or from a magazine, and make a preliminary layout in pencil without considering details like the eyes, the eyebrows, or the mouth, because at this point we are interested in the volumes of the face. Then, define the main shadows, the middle tones, and the most illuminated parts with just three shades of flesh tones. It is best not to apply them as blocks of color, that is, isolated from each other. They should be lightly blended with each other to create a certain amount of unity and to illustrate the continuity of the surface of the skin.

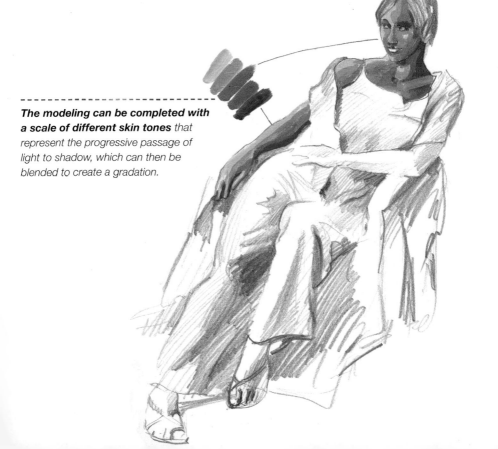

The modeling can be completed with a scale of different skin tones that represent the progressive passage of light to shadow, which can then be blended to create a gradation.

The Background
of the Portrait

The background should be chosen based on the effect you wish to convey with the portrait. You can opt for one that is simple and neutral, minimalist, elaborate, colorful, or dramatic, but always make sure that the subject stands out because the person in the portrait is the main point of interest and the background should not fight for your attention. Whether it is an interior or exterior, with a lot of light or little light, a well-executed background is an important complement.

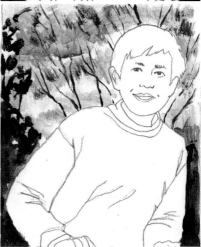

A completely black background creates luminosity and makes the face of the figure stand out so that the main subject dominates the image (a).

There are those who prefer not to use uniform backgrounds and create a gradation that creates an illusory sensation of light (b).

The sentiment that you wish to express is often linked to the background: a portrait of an individual in the middle of the outdoors cannot communicate anger, just the tranquil sensation transmitted by the background (c).

An Atmospheric Background

Sometimes corners of interiors are used as backgrounds, because they are harmonious and illustrate the environment inhabited by the subject of the portrait. It is important to heed a couple of pieces of advice if you are working with a fussy background: you must eliminate the distractions. For example, you can paint all the objects with a very small range of colors so than none of them contrasts too much. Placing the subject far from the background keeps it from disturbing the image, and it can be more easily softened or faded. An unfocused and suggested background is preferable.

Neutral and broken shades, which are softer and have gray or brown tendencies, are often used to cover the background, because they will not contrast very much with the subject of the portrait.

The Color of the Background

It is important to create a good relationship between the model and the space that is behind him or her. Whether the background is light or dark, with vibrant or subdued colors, the figure should stand out to make the presentation more attractive. Generally, the best backgrounds have a uniform tone, like smooth walls or the sky. Neutral backgrounds do not compete chromatically with the main motif. Gray, blue, and brown backgrounds are excellent backgrounds for portraits, especially when they are slightly gradated. The color should be of a medium or light intensity; if it is too dark it can be confused with the hair, and through contrast throw too much light on the values of the flesh tones.

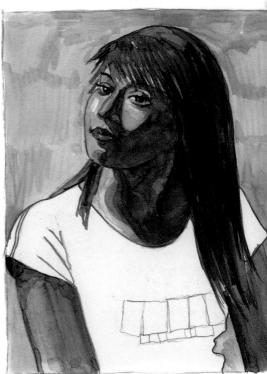

Neutral backgrounds are not distracting; they highlight the warmth of the face and hair.

The **Self-Portrait**

It is not easy to find a model who is willing to pose unmoving for a long period of time. But you can always fall back on the most patient and available models there: yourself.

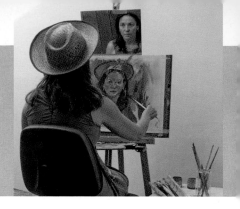

After mounting a mirror on the easel, this artist has put on a small straw hat to make the portrait more interesting.

 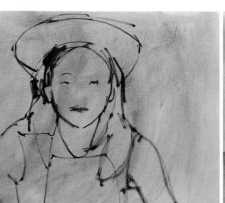

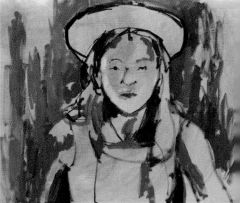

1. Cover the background with a little diluted carmine and ochre. Wait for a few minutes for the turpentine to evaporate then draw the figure with transparent terra rose as if it were a quick sketch.

2. This is not based on a solid and well-structured drawing, but on the loose brushstrokes that you will complete with the first applications of oil colors. Use earth tones mixed with green for the background and variations of transparent terra rose on the figure.

The self-portrait gives us an opportunity to scrutinize our own faces, with the advantage of painting something that we already know very well, inch by inch. In addition, it becomes an opportunity for accentuating some psychological features that will enrich the representation, since we know the ones that we want to emphasize very well. Before you begin, you must attach a mirror just above the support about a foot and a half (0.5 meter) away, so that you can see your reflection in it.

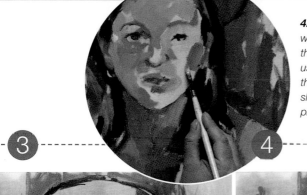

4. During the first phase, work with wide brushes because they apply paint quickly. Later, use a fine brush to construct the eyes and strengthen the shape of the face with more precise lines and strokes.

③ ④ ⑤

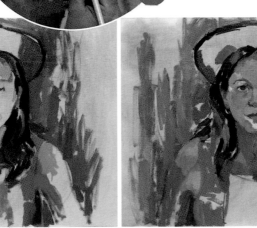

3. The flesh tones and the hair are constructed with a series of flat, juxtaposed brushstrokes. The areas in shade are painted with a gray color made by mixing the flesh color and green. The hair is painted with ochre, violet, and burnt umber.

5. The work now concentrates on the face. Finish drawing the eyes, the length of the nose, and the lips. Use transparent terra rossa mixed with gray and violet to create the shadows on the right side of the face.

6. *Incorporate turquoise blue into the flesh tones to represent the intermediate shadows. These should not contrast too much, but they should be blended with the adjacent colors with light brushstrokes.*

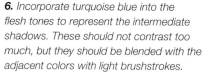

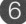

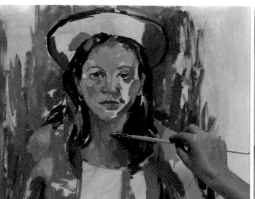

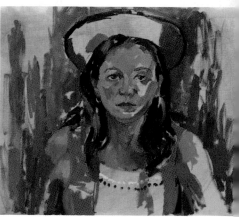

7. *The shaded half of the face is defined with the combination and blending of small blue brushstrokes. A whitish reflection is incorporated to make the face livelier, and the decorative embroidery on the blouse is suggested with light dabs of paint.*

8. *After the face has been resolved, move to the secondary elements, for example the hat, which is constructed with curved and built-up strokes of ochre shaded with gray and turquoise.*

AN OPPORTUNITY TO SCRUTINIZE OUR OWN FACES

9. *Finish the blouse with lightened violet and complete the shoulders with various flesh tones. The portrait has a loose style, and it is not strange to find unpainted areas where the background shows through. Use a fine brush for details like the earrings, and use a stick of charcoal to add some lines under the chin and on the arms.*

9

Representation and
Interpretation

When we talk about portraiture, we always think about capturing a likeness of the person's face; however, its essence goes much deeper. A portrait is not just a representation; it also implies the participation of the artist, in that he or she modifies, alters, and strengthens some aspects to ensure that the final image is much more attractive. When making a portrait, the artists consciously or unconsciously incorporates an altered vision of the forms, a personalized combination of color and a specific way of applying the brushstrokes, all of which comes together into a unique interpretation that reflects the character and personality of the painter. You must be receptive and try to perceive the various possibilities for interpreting the model, and then apply them to improve the final work of art.

Practicing the **Likeness**

To address the drawing of a well-proportioned portrait, it is important to have some general knowledge of the face and its features, but to achieve a likeness you must also pay attention to the details and make many adjustments until the drawing of an anonymous head becomes the portrait of an individual person. In this section we offer some advice for capturing the features that individualize the model.

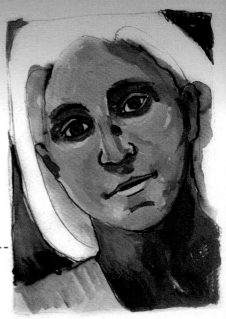

The eyes and the mouth are the most important parts of the face; they account for 80 percent of the likeness of the model.

When one part of the head is not working, you should cover it with one hand and try to create a mental image of how it should look. Then uncover the area, and make the changes that you have in your mind.

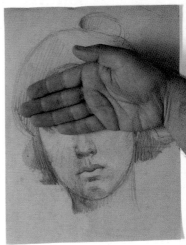

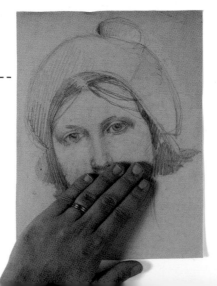

When you think the drawing is finished, it helps to cover and uncover different parts of the face with your hand to see if they can be improved.

The Keys to a Likeness

To make a good likeness of the facial features, you must render their shapes and develop them as very individual forms. You must perfect the features, try as many times as it takes to achieve a likeness, adding lines and constantly comparing distances to adjust them to those of the model. It is a slow process and requires many corrections. The eyes play the biggest part in making a likeness; it is important to pay special attention to them, and if necessary emphasize their shape, size, and color with a fine brush. The other key element is the mouth; it is possible to identify a person with just a drawing of his or her eyes and mouth. The rest of the features are not so decisive.

Checking for Errors

There is a method for checking the likeness of the model and identifying errors. Hold the drawing in front of a mirror to look at its reflection. Reversing the image will give you a new and objective view of the relationships among the parts, and you will more clearly identify the areas that need correcting. Another option is to cover the problem area of the face with your hand, imagine how it should look and uncover it to see where you have made errors. You will see the mistake immediately and can then make the correction.

Look at the reflection of the portrait in a mirror. If part of it is poorly proportioned or out of place, you will see the error right away.

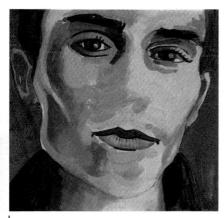

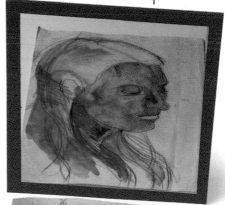

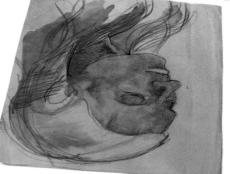

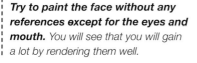

Try to paint the face without any references except for the eyes and mouth. You will see that you will gain a lot by rendering them well.

Hans Holbein the Younger
(1497-1543)

Born in Augsburg, Germany, Holbein is known as one of the great master portrait painters of the Renaissance. He started out painting murals, religious works, designs

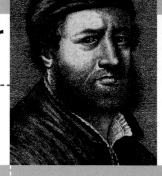

Portrait of John Poines, *1534.*
This drawing is of a painting of John Poines that seems to have not survived. It is an excellent portrait in which all the attention is drawn to the face, leaving the clothing, the head, and even the hair as loose sketches. The drawing was first done with charcoal, ochre, and color chalks for the flesh tones and silver point for the strands of hair. A thin dark line of india ink drawn with a metal nib pen adds greater definition to the face. This drawing probably was to be transferred to a support before painting it in oil.

Hans Holbein the Younger is recognized as one of the great master portrait painters of the Renaissance.

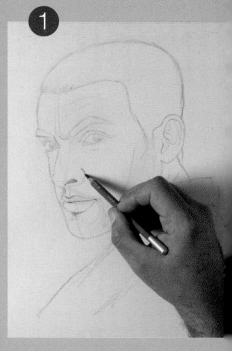

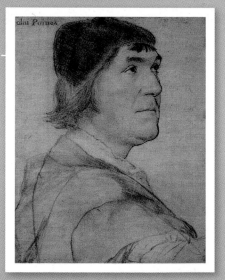

1. Block in and draw the main features of the model with a charcoal pencil. The line should be extremely fine and made with a minimal amount of pressure; otherwise, you will not be able to erase or correct it.

for stained glass, printed books, and, occasionally, portraits in a late Gothic style, but by the arrival of the Protestant Reformation, his style had been enriched by the new contributions of the Italian Renaissance. In 1532 he traveled to England and stayed there a few years working for the court. His portraits of the royal family and of the nobility are notable for their realism and modernity; many specialists rank his portrait work among the best of the era for the sureness and exceptional precision of his painting, for the penetration into the psychology of the person, and for the richness and purity of his style.

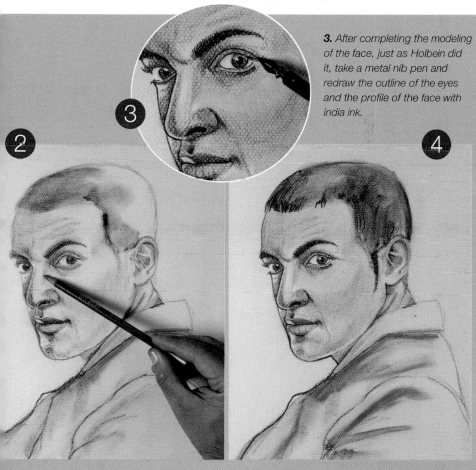

3. After completing the modeling of the face, just as Holbein did it, take a metal nib pen and redraw the outline of the eyes and the profile of the face with india ink.

2. Apply shading to the hair and clothing with a stick of charcoal. The flesh tones are built up by coloring with sanguine, sepia, and ochre chalk pencils. Once again, the pressure applied to the pencils should be minimal.

4. The result is a drawing constructed with great delicacy. The flesh tones are lightly modeled with different colors of chalk and charcoal, and the shape is reinforced with a thin dark line.

A Stylized
Interpretation

Here we draw a colorful portrait of this young man using a very uninhibited drawing and a Fauvist interpretation of the colors.

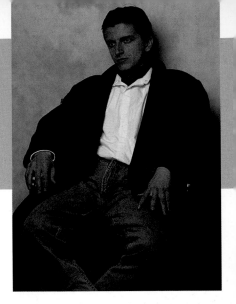

1. Start with a support that was previously primed with acrylic paint so it would dry quickly. Block in the figure over the background with a stick of charcoal, sketching only the most important shapes.

1

2

2. Finish the very stylized charcoal drawing, which creates a likeness with only simple geometric structures. Reinforce the lines with a dark color, a very diluted burnt umber.

3. Mix some of the burnt umber from the palette with dark ultramarine blue for the dark areas. Paint the dark color of the overcoat with very diluted color so it will not soak the background.

A portrait is not always a representation of a person with the greatest possible amount of detail. It can also be interesting to make a psychological interpretation based on a minimalist drawing, with a limited color palette. This approach does not present any great difficulties, but it is necessary to use your imagination to plan the different shapes and colors. The following work combines acrylics and oils on the same support.

4. Paint the entire overcoat with thick dark blue paint, allowing the background color to show through in some places. Paint the shirt in the same way, with diluted white. Begin adding gray tones with a lot of white to the face.

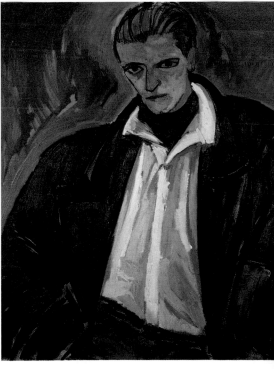

5. Accentuate the white colors of the shirt in the brightest areas, and then apply light grays. Suggest the wrinkles in the coat with very dark shades of blue. Finally, vary the color of the background with some warm tones.

Creating the **Flesh Tones**

There is no actual universal skin tone; the flesh tones are all free interpretations. However, in this section we will show you some mixtures that are often used in the creation of skin tones in a portrait. Certain tones are considered common to all types of flesh colors, while others are only used for working on the shading. Let's see what they are.

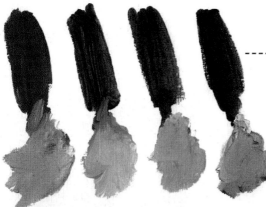

- -

These are the most used colors for creating flesh tones. They are mixed with a large amount of white and shaded with some yellow and even violet.

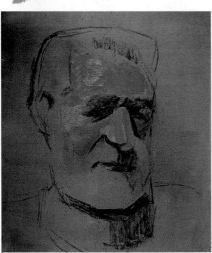

1. The best school is practice. Cover the most illuminated areas with a mixture of ochre, carmine, and a large amount of white, in uneven applications.

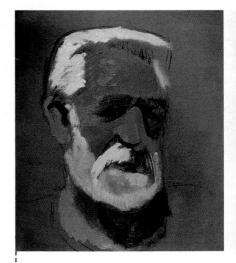

2. Construct the beard using white tinted with ochre and a bit of sienna. Then darken the neck using sienna mixed with a touch of violet.

The Colors That Should Be Used

Some painters begin with a basic flesh color made of a mixture of carmine, yellow, ochre, sienna, and, of course, white. These colors are then shaded with a dab of vermilion, carmine, yellow, or magenta (with the pretext of varying the coloration exposed to different light conditions), but they are shaded mainly with titanium white, zinc white, or Naples yellow. Others prefer more daring color combinations, with very saturated reds, carmines, and yellows. It is exciting to experiment when painting, since we have the medium in our hands (the paint) and a particular view of the subject in our mind; each artist is free to use these means in the way he or she thinks is best.

How to Apply the Color

In addition to the colors chosen for creating the skin color, when the paint is applied to the support, you must alternate the tones in a way that the strokes of different colors blend with each other. This creates unity and continuity in the skin tone. When working with opaque colors, first use diluted paint. As you add new skin tones and shades use increasingly thicker and creamier paint to make the skin seem more solid; however, do not mix it very much with the previous layers of paint.

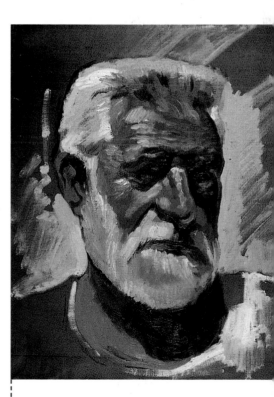

3. Use different tones of more or less whitened sienna to paint the shadows of the eyes. Then emphasize the main highlights and reflections on the face with very light ochre.

4. The strong sunlight reveals numerous wrinkles and small shadows that are painted with a fine brush, using carmine and burnt umber.

Flesh **Colors**

Some artists with little experience believe that there is a flesh color that can be applied to all figures, but this is not the case. Although it is true that some colors like pink and ochre are usually among the flesh tones, their use depends on

To mix a basic flesh color, use a white base and add carmine and yellow to it.

For a warmer coloration, mix vermilion, ochre, and white.

Any flesh tone can be shaded by adding ochre and darkened with a little burnt umber.

When the skin is more pink than brown, it is best to mix carmine with white and blend it with a little violet.

the conditions of light, the contrasts with the background, and the warm and cool tendencies of the model's skin. You can achieve numerous variations of flesh color by mixing, depending on the color range used by the artist. Let's look at some of the most common ones.

Burnt umber and transparent terra rosa, mixed with white, are colors that cannot be left out of the skin tones.

If you want to make a skin tone with a salmon shade, just mix orange and white; then adjust the final tone with violet.

Here is an uncommon mixture, a skin color resulting from a mixture of light violet with yellow and a great amount of white.

The combinations of sienna, burnt umber, violet, and a touch of white are usually reserved for persons of color or those who have strong suntans.

THE SUBJECT

The Color of **Shadows**

When painting the flesh tones on a face, you must work with tonal scales or gradations that range from the most illuminated areas, where the color looks whiter, to the darkest areas, which are the ones in shadow. You must darken the mixture with different colors according to the situation and the intonation of the skin color. Next, we offer different combinations of colors to darken the flesh tones; all of them can be used as a starting point for experimenting with different possibilities.

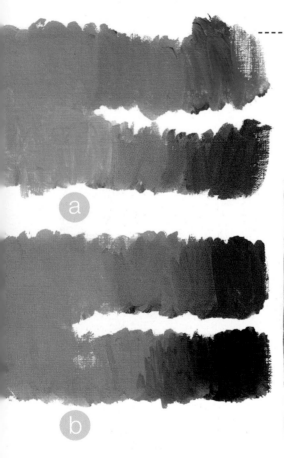

When the color of the skin *has a pink tendency, you can use blues and greens to create the shadows (a).*
 For a warmer skin tone artists usually mix transparent terra rosa, sienna, and violet to darken the color and create the shadows (b).

The shadows on this face *were mixed with sienna and a few touches of blue and violet middle tones.*

The Colors of the Shadows

Skin tones with a warm tendency are usually darkened with burnt sienna or transparent terra rosa, carmine, and even violet. When creating the shadows for skin tones that have a pinker intonation, it is best to use cobalt blue in the middle tones and permanent violet and cobalt blue in the darkest areas. All these colors, even the blues, add a purple shade to the shadows. Another approach is to darken the skin with the colors that surround the figure, so if a background is green, the same color can be used to darken the flesh colors, which will help integrate the portrait into the background.

Harder Shadows

The way you use dark colors like burnt umber, permanent violet, Payne's gray, and black depends on how much you wish to contrast and even dramatize the play of light and shadow. You must not forget that the burnt sienna can be darkened with a few light dabs of ultramarine blue, which will give you new mixes that you can use to create the shaded areas. Portraits of males can be painted with contrasting shadows to give them character, while female portraits should be painted with the lightest possible colors. The gradual movement from the dark areas can be painted with raw and burnt sienna, but do not use too much of the latter.

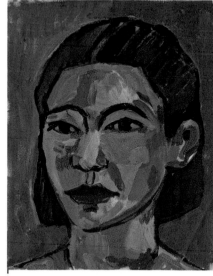

The colors surrounding the figure can have an effect on the shadows; here the green of the background makes an appearance in the shading on the face.

Advice About **Clothing**

Clothing should be a secondary aspect in half-figure and full-figure portraits. It should not become a place where you give free rein to your virtuosity and interest in details; on the contrary, it must be treated in an economic manner, and, if possible, even with austerity, so you can strengthen the features of the model and avoid drawing the attention away from the true focus, which is the face.

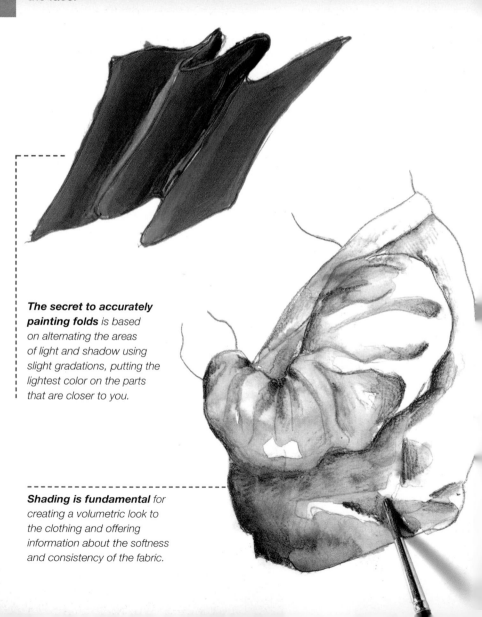

The secret to accurately painting folds is based on alternating the areas of light and shadow using slight gradations, putting the lightest color on the parts that are closer to you.

Shading is fundamental for creating a volumetric look to the clothing and offering information about the softness and consistency of the fabric.

Synthesis Is Important

The easiest way to draw clothing in a portrait is to simplify it. Block it in with geometric shapes as you would any other object, taking care not to render details like small folds or the texture. The first sketch should indicate the general look of the clothing, that is, how it fits the body, with simple drawing. This blocking in should show whether it clings to the body or hangs, and the folds that coincide with the articulations of the limbs. Based on this, you can begin to paint.

Folds and Wrinkles

After drawing the clothing, cover it with a very generalized layer of color, differentiating the illuminated areas from the dark ones. You must pay special attention to the variations in the colors, how they become lighter or darker depending on whether they are in a lighted or shaded area. The shadows appear on the insides of the folds, the recesses, while the parts that stand out more are lighter in color. This all contributes to giving the clothing volume and showing the folds that appear in it. The contrasts of light and shadow are also important for emphasizing a lapel, the collar of a shirt, or a pocket. The stiffness, softness, and contrast that go into defining the wrinkles in an article of clothing communicate much information about the nature of the fabric of which it is made.

One of the most interesting aspects of the clothing in a portrait is the possibility for colors that can add interest to the representation.

The main challenge of representing an article of clothing is recreating the folds in the fabric, which can be approached by placing shadows in the recesses of the folds.

Full-Length
Portrait

A seated model is an excellent opportunity for making a full-length portrait without resorting to formats that are too tall.

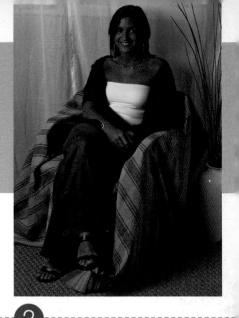

1

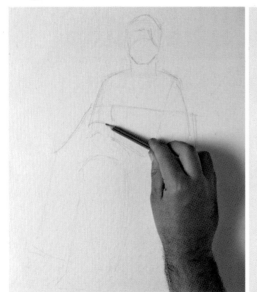

2

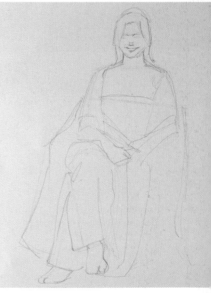

1. Place the main forms of the figure with a pencil. Start with an oval to describe the head, and work your way down the figure. The line should be light and made with the side of the lead.

2. The line must be lively and light, and continually corrected. The first goal is to indicate the length and the position of the figure, and then to focus on the head, the main subject of any portrait.

Full-length portraits show the complete view of the entire figure, from the head to the feet. There are two ways of making a full-length portrait of a model: with the figure standing or with the figure sitting. The first requires a very tall format, while the second will fit better on the standard sizes of stretched canvases available on the market. In this acrylic exercise we will create a very tight and realistic interpretation of the seated life model. It will require close attention to detail, especially in the first phases of the blocking in, and an individualized treatment of the face.

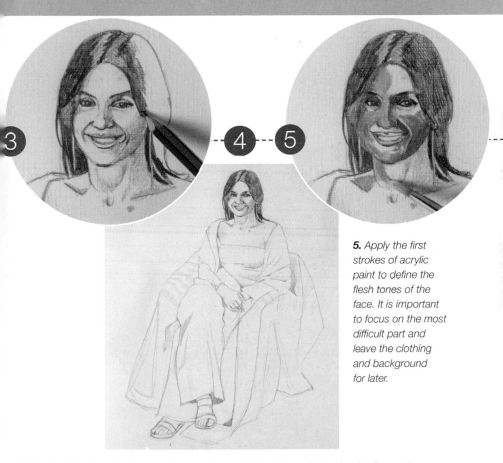

5. Apply the first strokes of acrylic paint to define the flesh tones of the face. It is important to focus on the most difficult part and leave the clothing and background for later.

3. The drawing phase is the most important. Everything should be very well defined before the painting begins. The face will have the most detail. The upper half of the body should be drawn very accurately, while the legs still look sketched.

4. Continue refining the details, working slowly and carefully with the sharp point of the pencil. Try to make the features look like those of the model, creating a strong likeness that will later be firmed up when the paint is added.

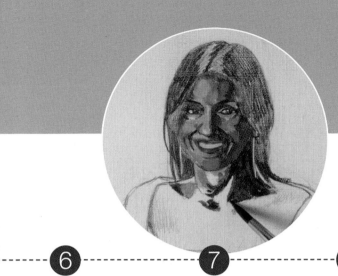

7. *Put each tone in place to firm up the distribution of light on the face and neck. The edges of each color should be lightly blended with the color next to it to improve the modeling.*

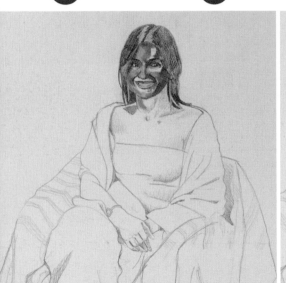

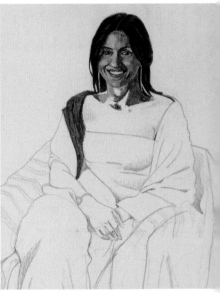

6. *Use a mixture of carmine, white, and a touch of yellow ochre to paint the lightest, rosiest flesh tones, and burnt sienna and burnt umber will be more visible in the shaded areas.*

8. *The fast drying acrylic paint allows you to apply new layers over the previous ones to model the color of each part of the face. This will allow you to reduce the contrast of the shadows and better integrate the lightest areas.*

9. *To complete the head, all that is left is to paint the hair with a mixture of burnt umber and black. Use a fine brush to detail lines of the eyes, the base of the nose, and part of the mouth. Use the same colors on the shoulders, neck, and the arms.*

10. *The forearm requires a large amount of gradating from the light areas to the shadows. The shawl can be painted with a mixture of diluted red and magenta, applied as a base color.*

A SEATED FIGURE FITS BETTER ON THE STANDARD SIZES OF STRETCHED CANVASES

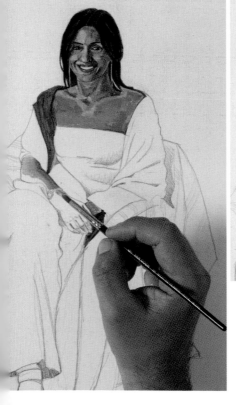

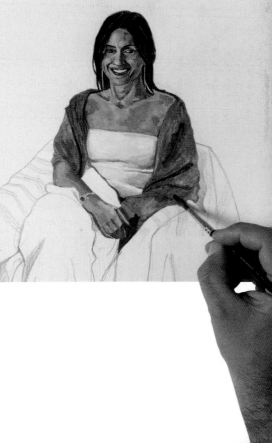

11. *After the head is finished, the body can be painted more quickly. Use different proportions of ochre mixed with violet to paint the cover of the sofa, indicating the main areas of shadow.*

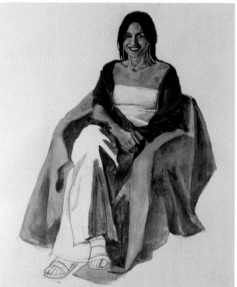

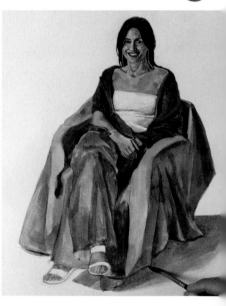

12. *After the ochre base has completely dried, strengthen the shadows of the folds of the sofa with a violet glaze. This same color, mixed with red, should then be applied to the darkest part of the pants.*

13. *In this phase the acrylic paint is much more like a wash. The goal is to quickly finish covering the clothing and the sofa. Add thicker paint on the folds to describe the shadows in them.*

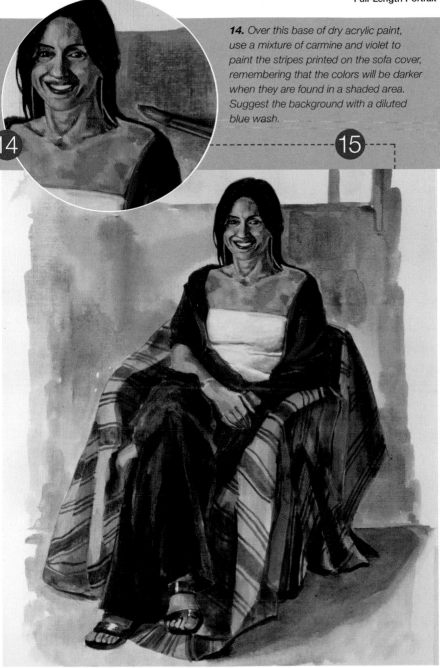

14. *Over this base of dry acrylic paint, use a mixture of carmine and violet to paint the stripes printed on the sofa cover, remembering that the colors will be darker when they are found in a shaded area. Suggest the background with a diluted blue wash.*

15. When the background, created with blue and green washes on wet, and the floor, barely suggested with a wash of ochre, are finished, the portrait is considered complete. The simplicity and uniformity of the background focuses all the attention on the model's face.

The Stylistic **Approach**

Portraits of people are not always linked to a realistic interpretation, which attempts to describe every tiny detail with great ability and perfection. There is another kind of portrait, very loose, sketchy, and synthetic, that in just a few lines is able to capture the physical features that best identify the subject and his or her character and attitude, illustrating them in a simple and understandable manner. Despite the economy of this graphic style, any viewer will easily be able to identify the person who is represented.

- -
Block shadows very accurately render the features of the subject by contrasting them with the clearly illuminated areas, which are left the color of the paper.

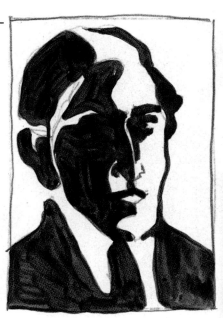

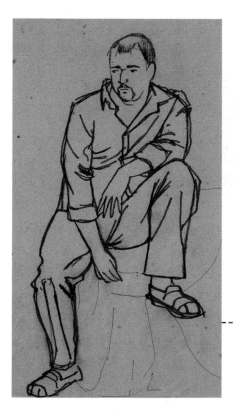

- -
This simple drawing combining black chalk and a marker attempts to capture the posture of the model and his features in a very stylistic manner.

Minimal Indications of Expression

A stylized or synthetic portrait is a way of painting a subject using an extremely simple drawing indicating the structure but with few details. To create this, you must look for the minimal indications of expression in the model. This means that for the likeness to be successful the drawing should mainly emphasize the two or three most important characteristic elements of the subject's physiognomy that will make him or her especially recognizable, while ignoring the rest. It can be said that a stylistic portrait avoids being a realistic treatment so it can be a better conceptual representation.

An Expressive Painting Style

A stylized painting cannot be painted in the same way as an academic or conventional one; neither the colors nor the brushwork should be the same as in those styles. Expressionist and Fauvist interpretations, with their flat colors applied flat and loosely, with vivid contrasts, are most similar to this kind of portrait. The color is usually not closely related to reality; the paint is applied roughly and in a purposely clumsy manner to create the drawing with loose and dynamic brushstrokes.

A stylistic interpretation of the portrait allows a very free painterly style that is much more contemporary.

Fauvism is a style that adapts very well to a loose and general treatment. Here the brushwork and the use of unusual colors become very important.

THE SUBJECT

Depending on the **Caricature**

The caricature is a drawing technique that attempts to create a likeness of the person by emphasizing or distorting his or her features, disproportionately increasing their defects or attractive points. The appearance of the portrait is that of the subject, but its components are purposefully altered.

Caricatures are based, mainly, on a process of reduction and exaggeration, changing the components of the face.

In this subject the eyes, the eyelashes, and the size of the lips are emphasized to make the drawing more feminine, all accompanied by a very characteristic beauty mark.

How Do You Draw a Caricature?

Caricatures are primarily based on a process of reduction and exaggeration of the physiognomy of the components of the face. The satirical effect caused by this comes from the pleasure produced by the contrast between the real and the implausible, between the likeness and the equivalence. There is a caricature hidden in every face; you only have to find the most characteristic features and try to exaggerate them. That which can be perceived as a good likeness in a caricature, and even in a portrait, does not have to be a replica of something you see, but an abstraction of a real person.

Pay Attention to the Psychological Features

The distortion produced in a caricature does not only accentuate the physical features of a specific person, but the psychological ones as well. This means that a good caricature does not settle for representing the physical aspects, but attempts to capture the character and temperament of individuals, who can be cruel, calculating, proud, sinister, shy, etcetera. You must search out what the psychologists call "minimal indications of expression," which requires paying close attention to the physical and sociological reality of the subject. Any piece of information relevant to his or her personality should be taken into account and used in the creation of the caricature. You are a good portraitist only if you can delve into the spirit of the model.

A caricature focuses on the most characteristic feature of the subject's face and gives it more relevance than it has in reality. In this case the artist strengthens the portrait with an oversize nose.

- -

Many caricatures are very attractive interpretations that emphasize the artistic and decorative effect, but you must never lose sight of the similarity to the real subject.

Chiaroscuro Portrait in an **Interior**

The model is seated at a small table in a thoughtful pose. The little lamp is the only source of light in the setting, resulting in strong contrasts.

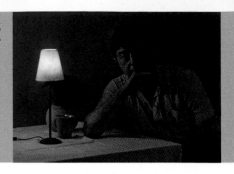

1. *Use an HB pencil to make the preliminary sketch. Try to capture the main forms, and little by little continue to make adjustments to the model. The line should be light so it can be erased as many times as is necessary.*

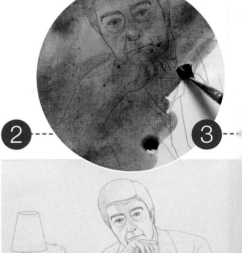

2. *Now focus all of your attention on the head, noticing the details that will capture the likeness. The rest of the body and the objects that are on the table should be drawn in a simpler manner. It is important to spend all the time that you need on this phase of the drawing, because it is the most important part of the work.*

3. *Spread a wash of ultramarine blue acrylic paint mixed with a touch of black over the entire surface. Wait for a few minutes until the background is dry.*

Chiaroscuro is a very common technique, used when the subject is illuminated by a nearby single light source, which might even be placed within the scene itself. These light conditions create strong contrasts of light and shadow, emphasizing the relief on the face, which gives it greater expression and character. This implies a brusquer modeling of the flesh tones and the incorporation of reflections and highlights on the most prominent parts of the face. The dark background helps emphasize the tenebrist atmosphere of the scene.

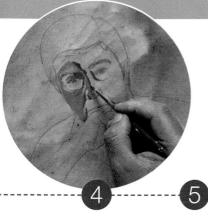

4. Use oils to build up the flesh tones on the face with progressive brushstrokes that fill in the spaces on the face like pieces of a puzzle. Each brushstroke should be lightly blended with the one next to it.

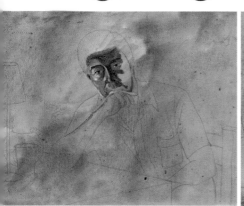

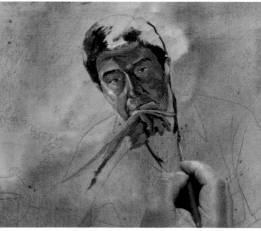

5. Add burnt sienna to the middle tones, and mix it with violet for the darker shadows. Starting with the middle tone blue background, use white highlights to move the exercise forward.

6. Paint the first dark areas of the hair and the shadows of the shirt collar with burnt umber mixed with violet. Then immediately sketch in the hand using a mixture of various skin tones, outlining the fingers with fine dark lines.

7. The arm will be modeled with different ochre, sienna, and violet tones. The elbow should show signs of being nearer the light source, so the flesh tones must be warmer and quite light.

8. Cover the background with thick, dense oil paint: lightened cyan blue around the lamp, cobalt blue around the figure, and ultramarine blue with a little black on the right half of the painting. All these values should be blended to create a gradation.

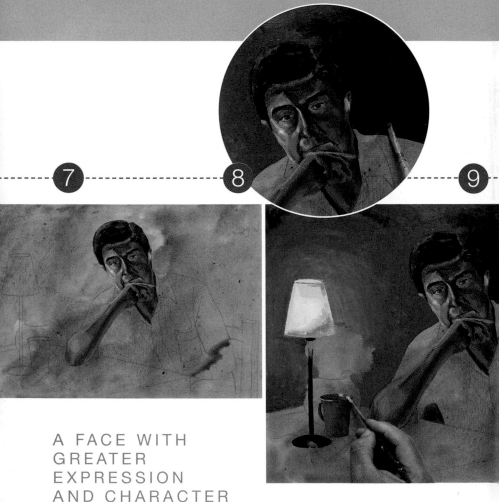

A FACE WITH GREATER EXPRESSION AND CHARACTER

9. Paint the lampshade, which is the source of light, with white tinted with a bit of yellow and orange. The rest of the objects should be resolved with two or three different tones, which can then be completed with strong highlights on their surfaces.

10. *The objects on the table, treated in a realistic manner, make an interesting counterpoint to the face of the subject, which is very well modeled and shows a strong contrast between the illuminated and shaded sides of the face.*

11. *The rest of the painting is then finished in a loose manner. On the shirt only paint the areas where there are highlights, allowing the blue of the background to show through the rest. The tablecloth is painted with diluted white and gray, leaving unpainted areas where shadows are projected by the objects and the subject's arm.*

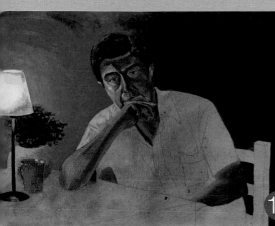

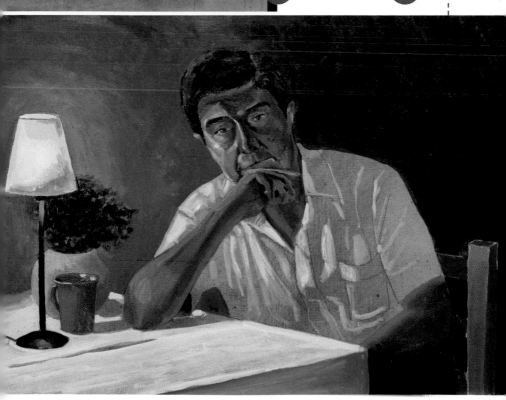

Vincent van Gogh
(1853-1890)

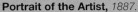

There are very few photographs of Vincent van Gogh. His characteristic factions are known through his self-portraits.

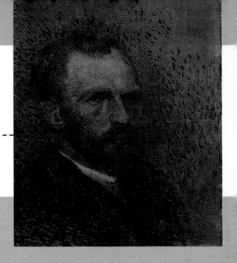

Portrait of the Artist, *1887.*
The artist produced around 30 self-portraits in just 5 years, this one being one of the most well-known versions. The artist's fixed gaze, intimidating and penetrating, is directed toward the viewer and transmits his strength and character. The curved brushstrokes and the spiral, agitated movements painted in the background suggest the troublesome rhythms of his tormented thoughts. The flesh tones range from Naples yellow in the lightest areas to a mixed green in the shaded parts, used, without a doubt, because they harmonize better with the blue that floods the background.

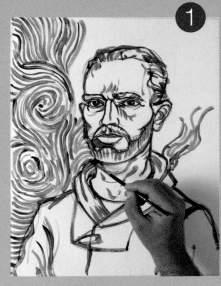

1. In this portrait of an individual with a beard, we will use the expressive techniques developed by van Gogh. Start with a pencil drawing, and then emphasize the outline and fill in the background with spirals using violet acrylic paint, which will dry quickly.

2. Apply some colors to the background, alternating cadmium red, cobalt blue, and lightened cyan blue. The paint should be diluted, and the brushstrokes should be long and wavy.

Van Gogh is considered to be one of the great masters and a precursor of the painting of the 20th century, especially the Expressionists and the Fauvists. His work is known for its particular use of color and for the symbiosis of line and color, as well as for the incorporation of intense strokes. Along with Rembrandt, he is one of the most prolific self-portraitists in the history of art, the indisputable subject of innumerable and varied versions, in many different interpretations and moods.

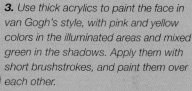

3. Use thick acrylics to paint the face in van Gogh's style, with pink and yellow colors in the illuminated areas and mixed green in the shadows. Apply them with short brushstrokes, and paint them over each other.

4. Complete the background with new brushstrokes, thicker this time. Use a dark line to reinforce the outlines of the eyes, the nose, and the mouth. Finally, cover the clothing with alternating applications of violet, sienna, and Prussian blue that are mixed haphazardly.

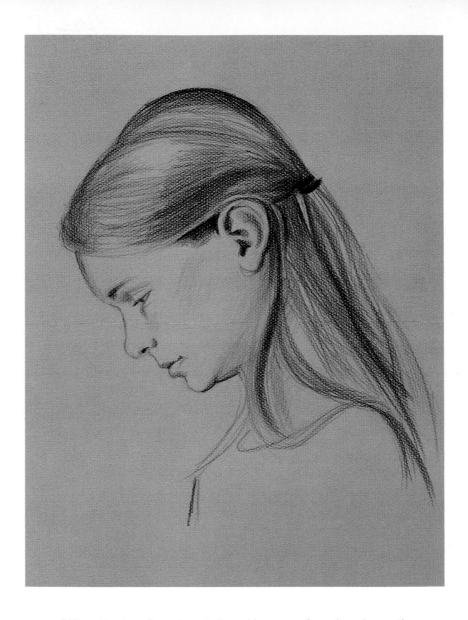

"Who, without much previous study, could express a face where the mouth, the chin, the eyes, the cheeks, and the forehead join in laughter or in tears? This must be learned from life, searching out the most fugitive aspects of the features and those that make the viewer imagine more than he sees."

León Battista Alberti
***The Three Books of Painting**, 1435*